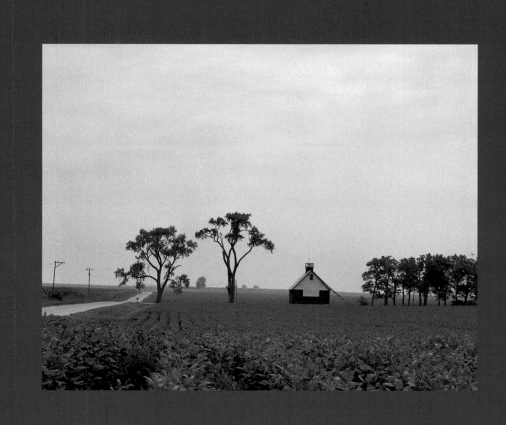

Barns of Illinois

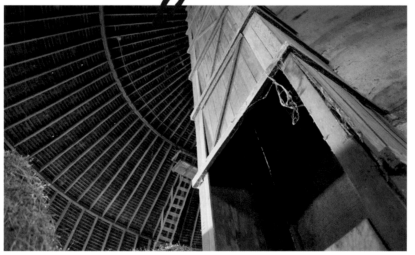

PHOTOGRAPHS BY

LARRY KANFER

TEXT BY ALAINA KANFER

UNIVERSITY OF ILLINOIS PRESS

URBANA AND CHICAGO

The University of Illinois Press is a founding member
of the Association of American University Presses.

Composed in Scala Sans Pro with P22 Gauguin display
by Jim Proefrock at the University of Illinois Press
Designed by Copenhaver Cumpston
University of Illinois Press

1325 South Oak Street
Champaign, IL 61820-6903
www.press.uillinois.edu

Library of Congress Cataloging-in-Publication Data
Kanfer, Larry, 1956–
Barns of Illinois / photographs by Larry Kanfer ;
text by Alaina Kanfer.
p. cm.
Includes index.
ISBN 978-0-252-03274-5 (cloth : alk. paper)
1. Architectural photography—Illinois. 2. Barns—
Illinois—Pictorial works. 3. Barns—Illinois—History.
4. Kanfer, Larry, 1956–
I. Kanfer, Alaina, 1962– II. Title.
TR659.K36 2009
779'.4773—dc22 2008041249

Contents

To the miracles

who inspire us every day,

Anna and David

— LK & AK

People often ask me to photograph one particular barn or another. I've always wondered, what is it about that barn that is so compelling to them? It's just a structure. But emotionally the barn they ask me to photograph is so much more. I am intrigued with what they see. What has happened within those walls? What are these people remembering or even imagining when they finally see the photograph of the barn? This project was an opportunity to answer these questions.

Our flat and open landscape in Illinois is composed of the sky, the earth, and the horizon line where they meet. Our crops embellish the landscape. The corn—"knee-high by the Fourth of July"—is a marker of time from its planting to the harvest. After one year the cycle starts all over again. But it is the barn on the landscape that marks our time passing through generations. We can observe the deterioration of a barn over decades. The restoration of a barn is a bright point in its history. We mark time by the events that take place in the barn: community barn raisings, first dates at a barn dance, the tornado that hit. Barns also help us mark space, providing us with navigation points in the countryside.

Driving through the countryside, barns inspire us. They help bring us back to bucolic ideals. Barns may still be just structures to the untrained eye, but they are places where people experience work, play, life, and death. It is the richness of those experiences that makes barns meaningful.

The photographs and stories in this book are my attempt to peel back the layers of architecture and history, to reveal the personal memories, the emotions, and the inspiration that barns spark in all of us.

Introduction

LARRY KANFER

Barns connect us from one generation to another. They tie us to our roots and ground us in our values. Steeped in Americana, they are comforting, reminding us of simpler times and hard work. Tending to barns from our past is a way of showing respect for those who have come before us. Connecting to our past helps us frame problems today, as we ask what our parents or grandparents would have done. And there is joy in continuity; it gives us a sense of pride in carrying on family traditions.

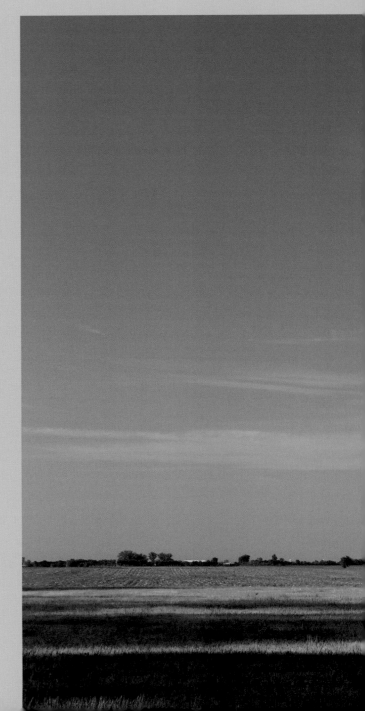

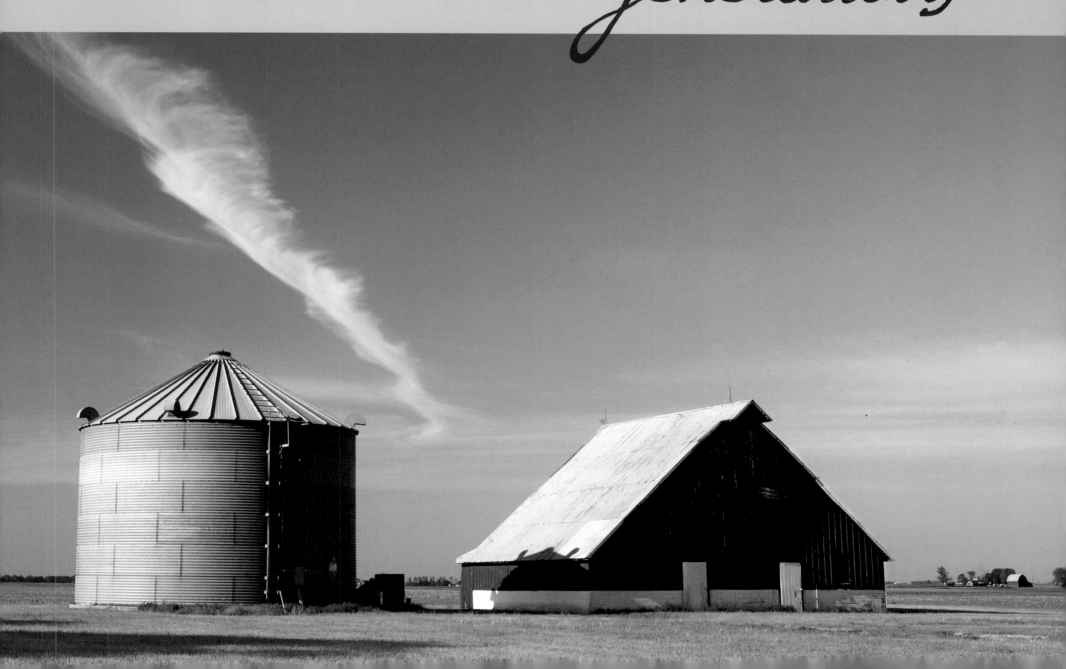

Generations

The original Paulson barn burned to the ground during the drought of 1934. With the help of many neighbors, the barn was rebuilt in 1935 and the Paulsons held a barn dance as a token of their gratitude. It turns out they were filling a social need in the community. When an astonishing six hundred or so people came to the first dance, the Paulsons decided to make their barn dance a Saturday night tradition. Starting with ticket prices at fifteen cents for women and twenty-five cents for men, the dances also brought income to support the barn. Today many Rockford-area families can trace their grandparents' first date to a Paulson barn dance. Hidden in the haymow, you can find the original bandstand and piano, along with a young lady's record of her dance partners written on the wall.

Jerry and Don Paulson have adopted their father's philosophy. They recall, "If ever our father made a dollar, he would use it to fix the barn." The Paulson barn remains an icon of everything important to the community, from the barn dances before World War II to the horse-and-buggy rides the Paulson brothers offer today.

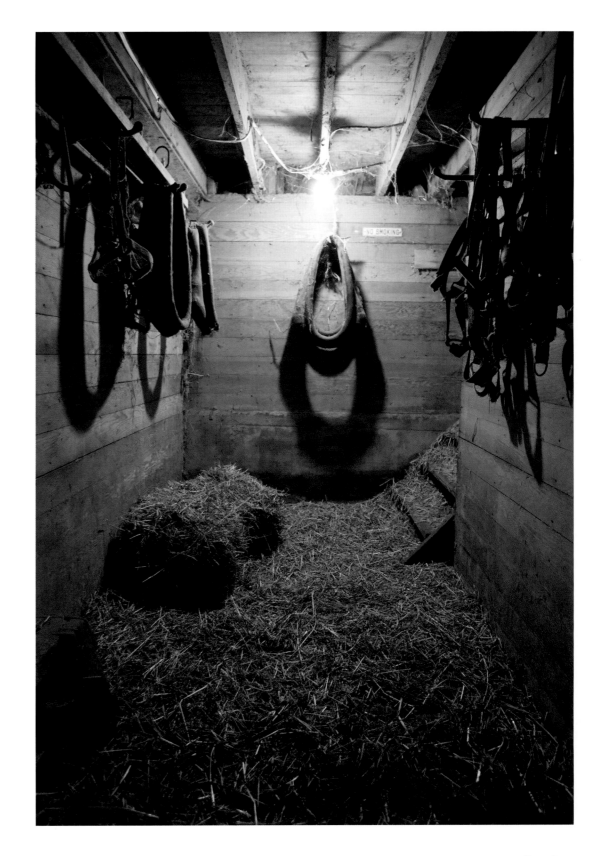

PAULSON BARN
WINNEBAGO COUNTY

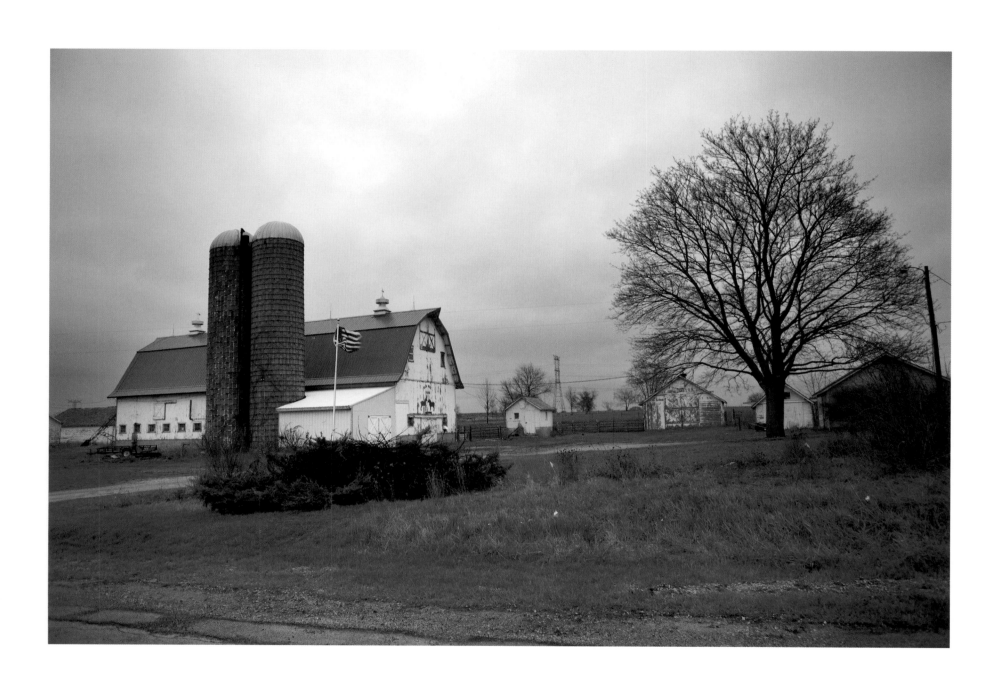

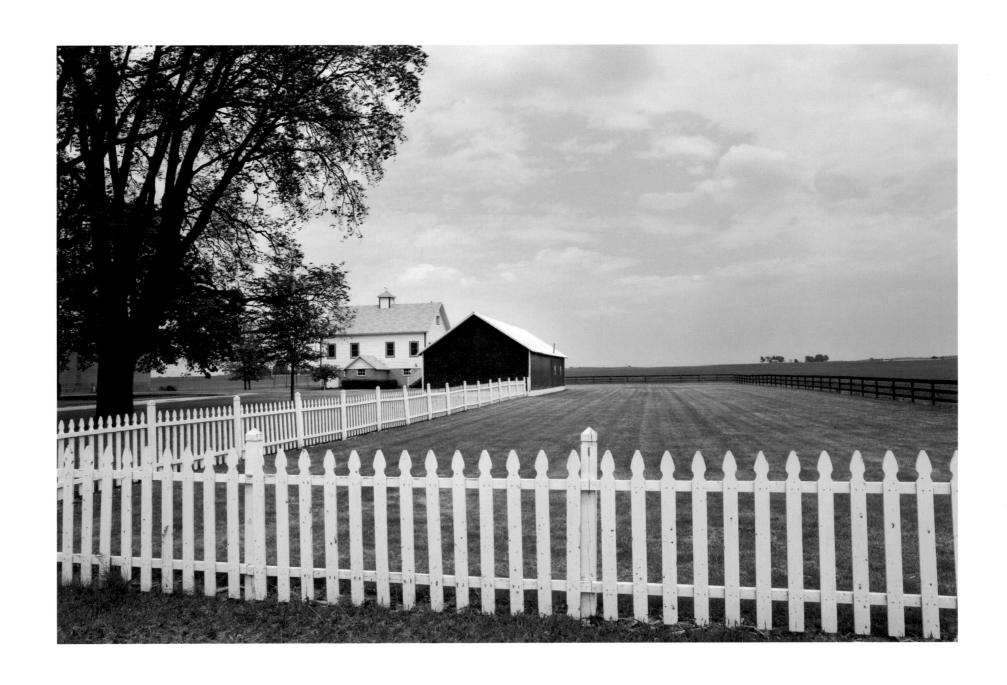

GERDES BARNS

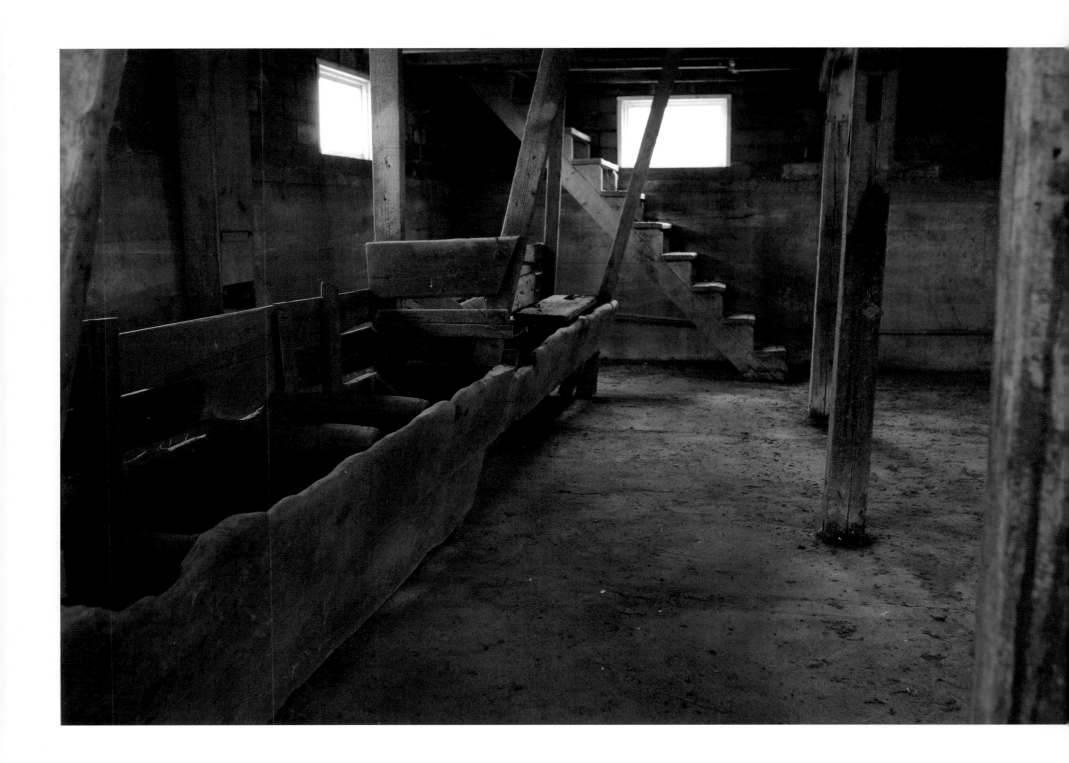

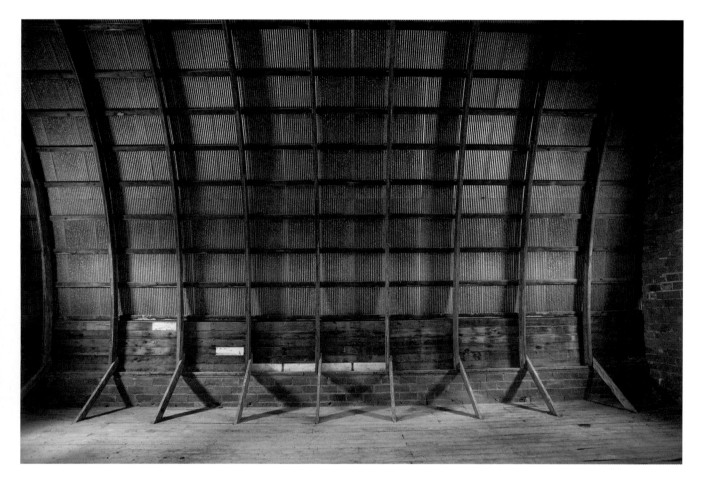

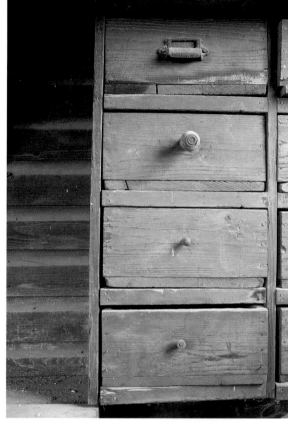

As a young boy, Steve Gerdes drove through the countryside with his father and his grandfather, both farmers. Without fail, they each would marvel as they approached one particular barn on the Wyanet-Walnut Road. Set on a modest farm with a modest farmhouse, this barn stood up and sparkled on the top of a hill: a first-class barn. Years later, when Steve grew up to be a successful businessman, he noticed that the barn from his childhood had deteriorated almost beyond repair. There were gaping cracks in its concrete foundation, but its spirit was intact. As a tribute to his father's and grandfather's ideals, Steve, his family, and VC Contractors restored this monument—tall and proud—as it was so many years ago. Today Steve and his family maintain and have saved several barns in the area.

GERDES BARNS
BUREAU COUNTY, LEE COUNTY

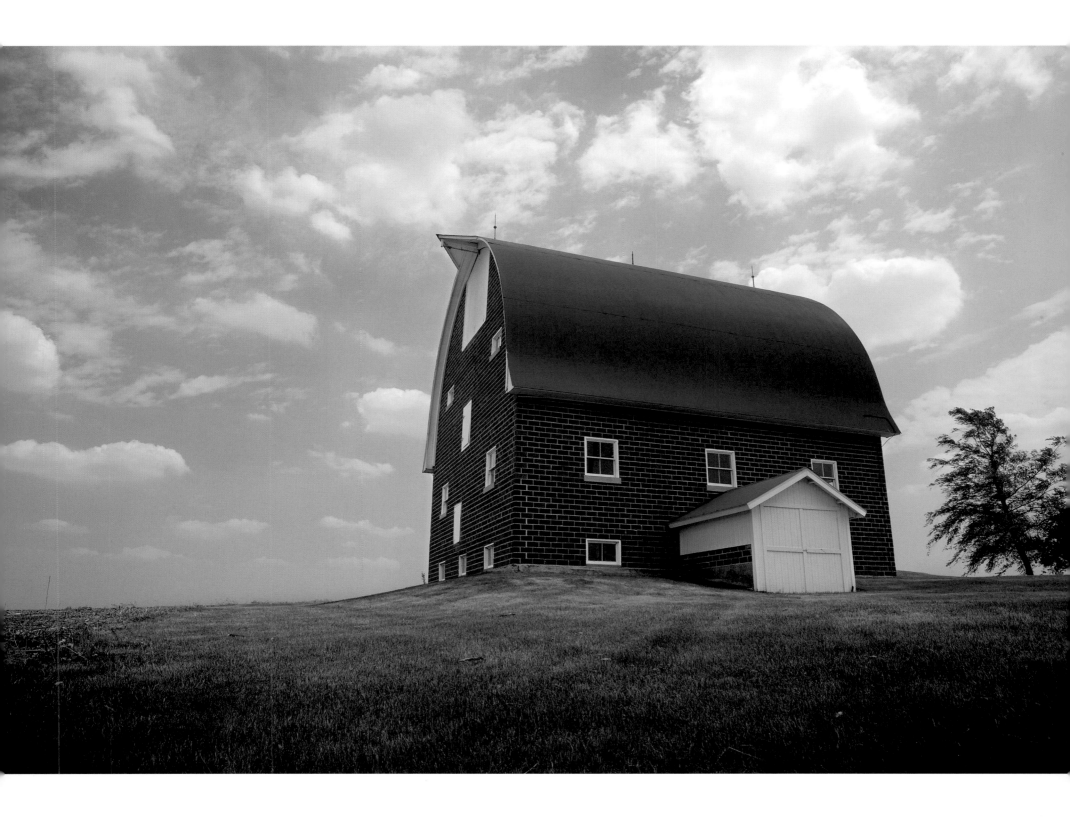

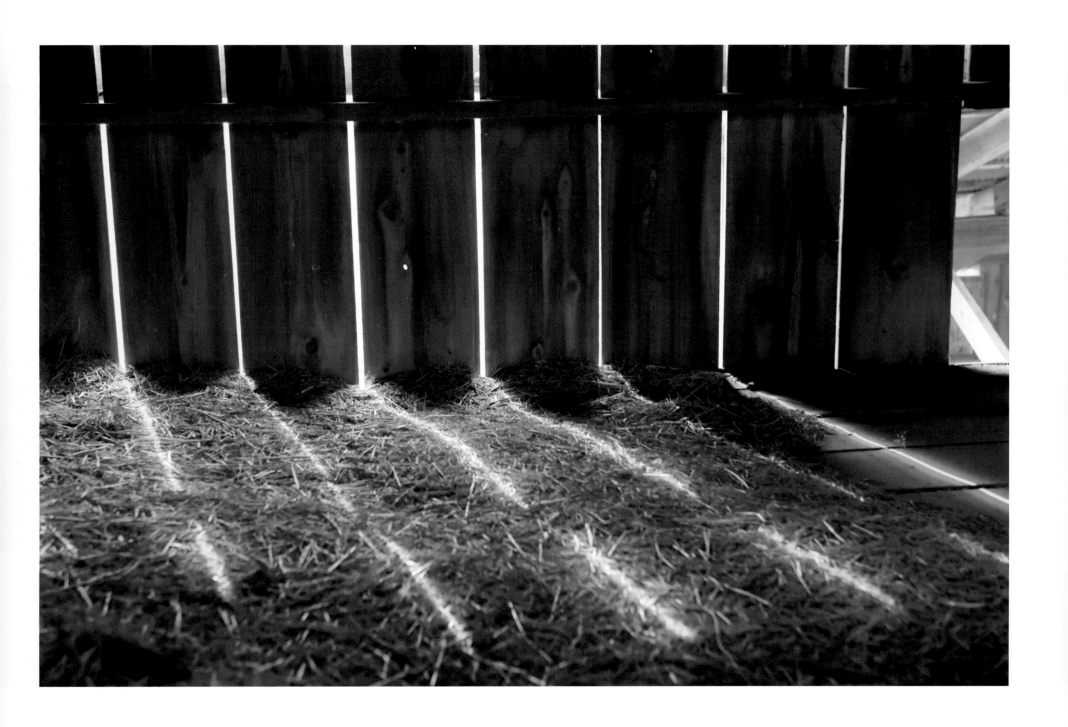

SUMMERS BARN
SANGAMON COUNTY

Sometimes a barn has a life of its own with connections to the community built over the years. Rose Lober-Hamilton and her husband, Rick, had an elusive dream of someday moving to the country from their Springfield home. It was Rose's hobby to spend weekends and free time driving around, checking out properties. One magical day, a realtor took her to a farmhouse outside New Berlin, Illinois. Rose walked in the front door and knew she was home. The Hamiltons bought the house from Robert and Margaret Summers, the end of a long line of ownership by the Summers family. Years later the new owners realized they had not just purchased an isolated piece of land in the country. A place in the social fabric of the community came with that land. When people introduce Rose and Rick, they always use a phrase that acknowledges the acceptance of the Hamiltons: they live in the Summers's place.

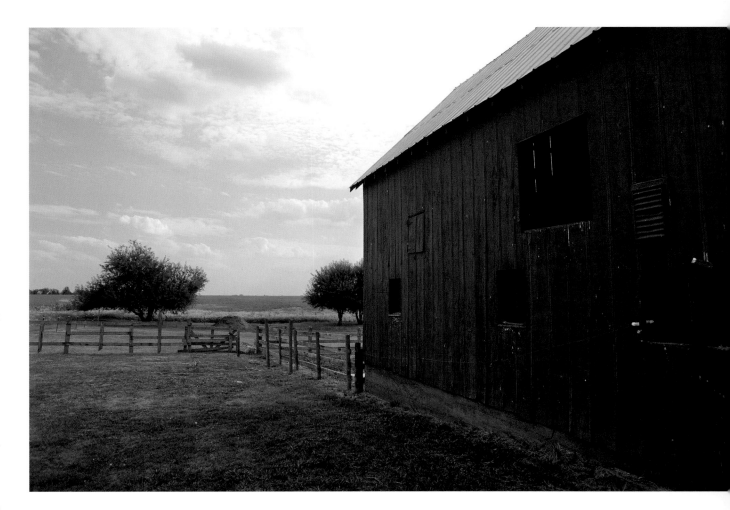

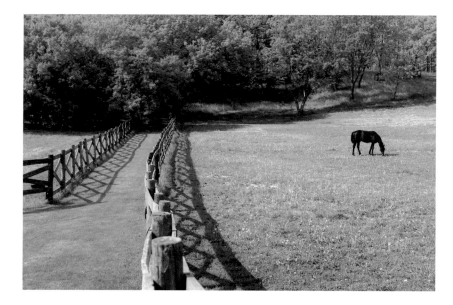

Robert LeRoy grew up in a small village in Hungary, one of ten children. The sounds and smells of his parent's barn and horse trade were pervasive throughout his childhood. After Hitler invaded, Robert's family was sent to Auschwitz in southern Poland, where his parents and most of his siblings perished. Miraculously, Robert was spared, and he remembers February 11, 1945, as his liberation day. A determined young man, Robert began walking from southern Poland back to his hometown in Hungary to reclaim his life and his family's livelihood. In early May that year, he arrived at his neighbor's door and demanded possession of his dad's barn. But it was not to be. The neighbor had taken over the barn and refused the young man's demand. The laws had changed, and people released from the concentration camps were effectively locked out of the economy.

Not one to give up, Robert made his way to America. He moved to Chicago, where he met his wife, Carol, and started a family. Robert and his remaining brothers applied the family knowledge they had grown up with and acquired and sold horses as a hobby. Even though they lived in a new country and a new city, they were linked to their roots by the horse trade. Finally, in 1975, thirty years after his liberation from Auschwitz, Robert had a homecoming of sorts. He purchased rural property where he moved his family, housed his construction company, and supported his horse trade. While he could not return to his life from rural Hungary, Robert LeRoy recreated the smells, sounds, work experiences, and comfort of his childhood, sharing them with his own children through the horses, racetrack, paddocks, and barn on his land outside Elgin, Illinois. The barn is the symbol of a legacy, connecting Robert and his children to his homeland.

LEROY BARN
COOK COUNTY

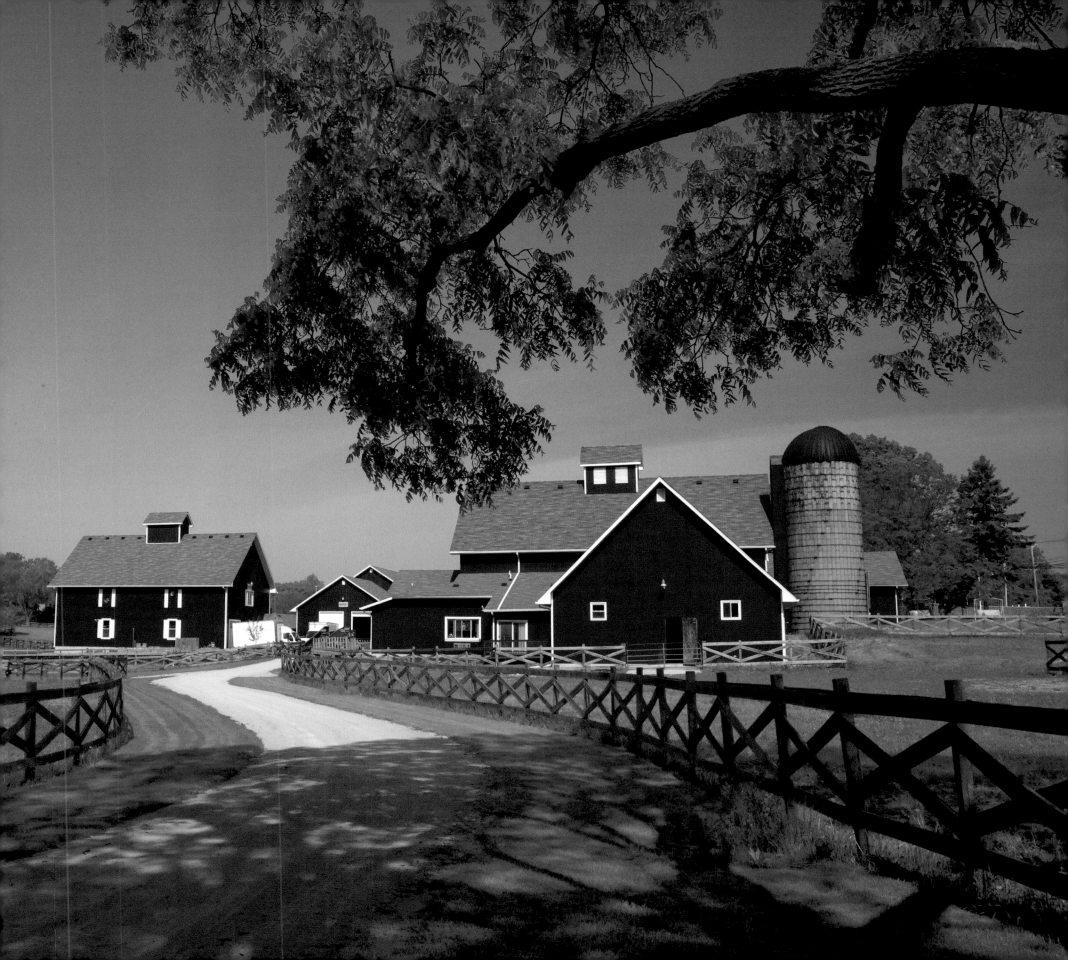

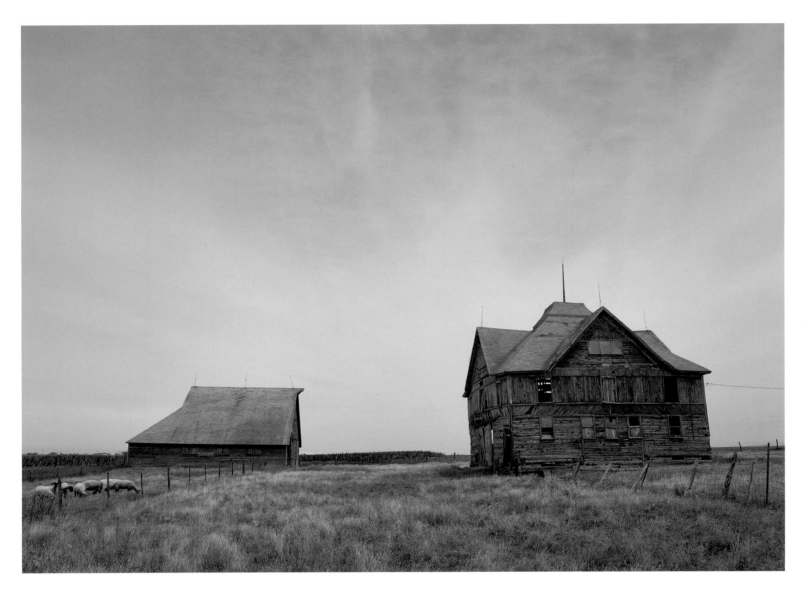

In today's mobile society, we sometimes look to physical reminders as ways to recall the memories and rituals embodied by barns. Dottie Williams has lived in twenty different houses over her lifetime. She moved to each new house three of the foundation stones from her grandfather's barn. Why has she lugged three huge boulders around the state with her?

She says, "This is my grandfather. All I have left are these memories." In each new place, she sets the boulders along her driveway, where they connect her to her family and continue to provide her with a solid foundation.

DONER BARN
MCDONOUGH COUNTY

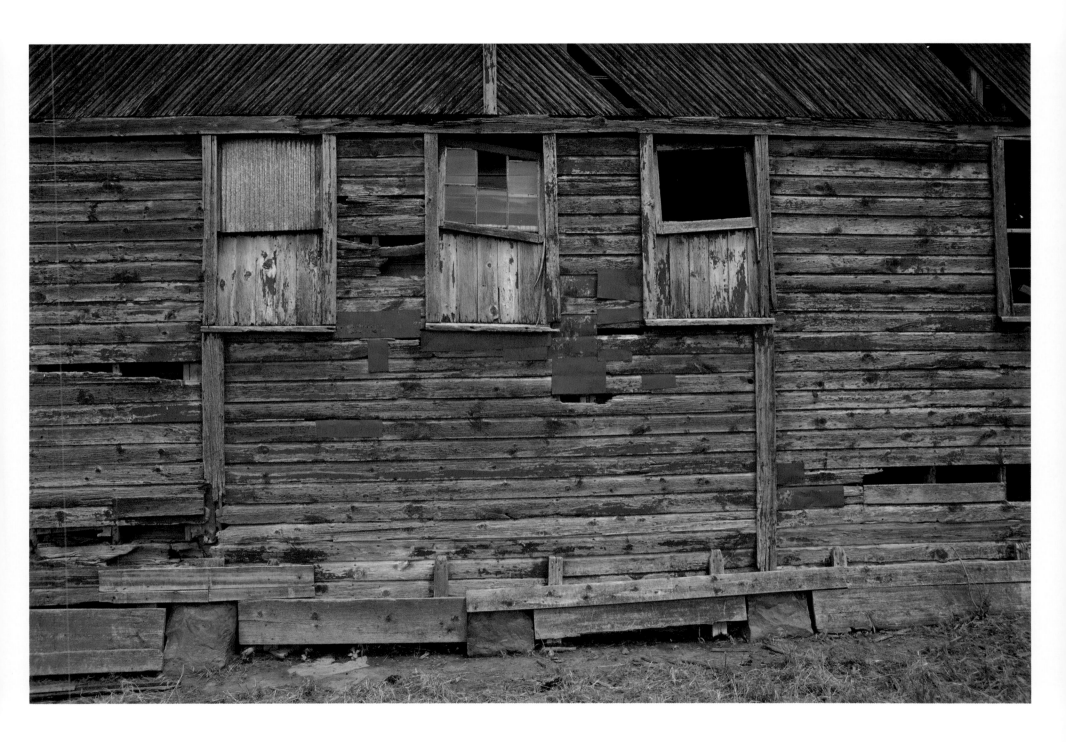

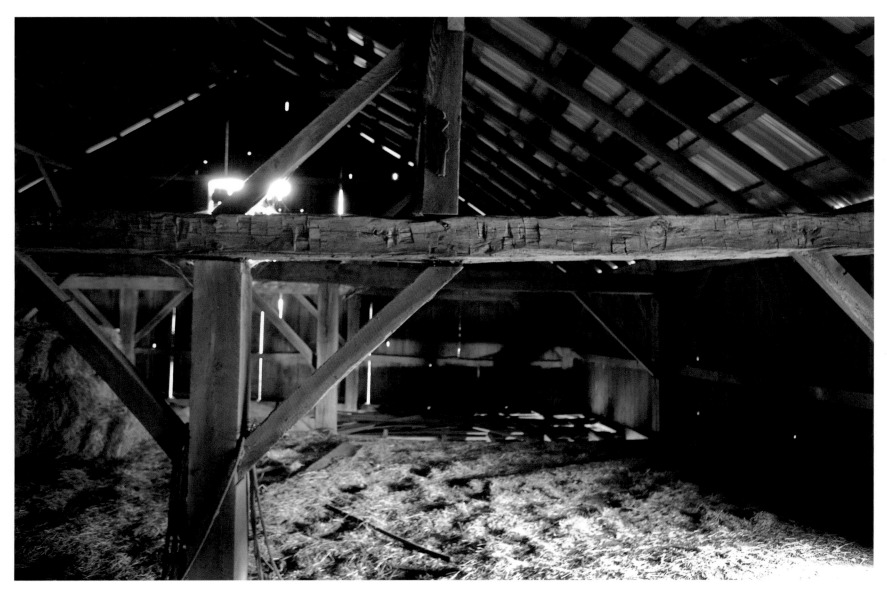

Each day that Roger Anderson walks into his family barn to tend the cows, he knows there is a wooden doll pegged to a cross beam in the loft. He remembers seeing it when he played in the hayloft as a child. His grandpa, who was born in 1907, told Roger that the doll had been there as long as even he could remember. The doll connects the barn's structure to the lives of those who have passed through its doors. The traditions have held fast over the generations on this same land. Feeding the cows. Family dinners. Fishing after dinner. And when Roger is doing his barn chores, he walks in his ancestors' footsteps. Very consciously he thinks, "I am honored to do this."

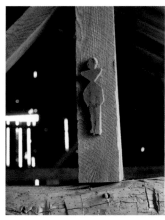

ANDERSON BARN
MACOUPIN COUNTY

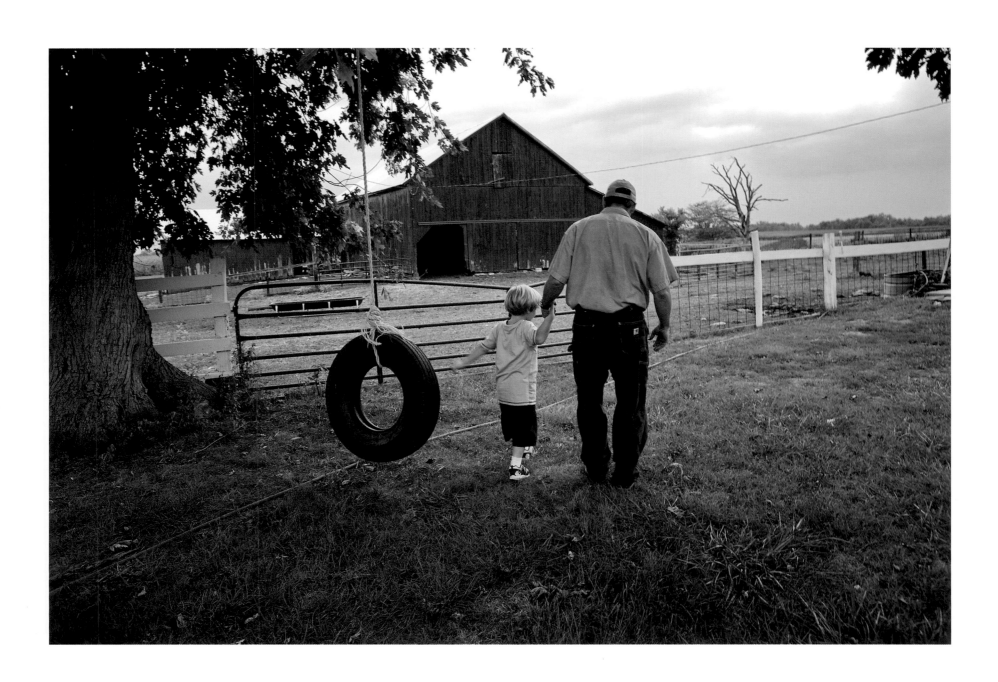

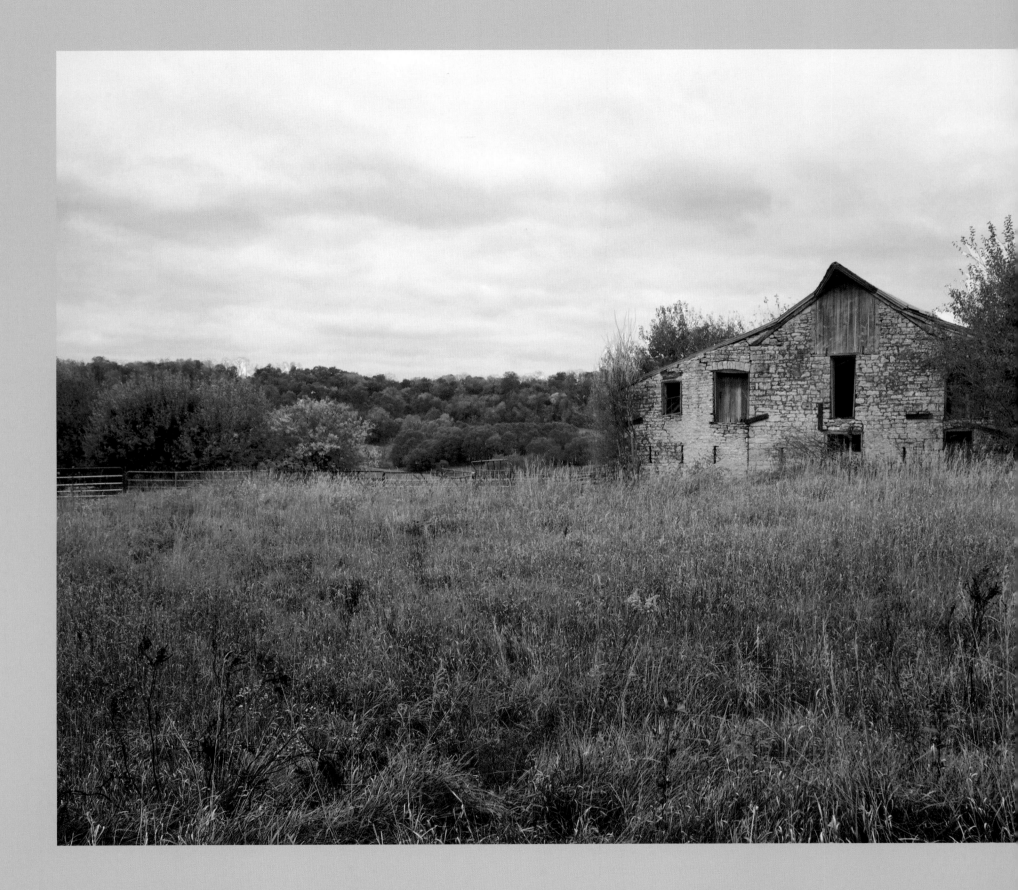

Barns across our state have been the location of many historical events. Actually seeing those sites provides us with a context and a sense of shared history. Once we see a real threshing floor, we can comprehend how difficult it was to thresh wheat, and we can recognize the significance of agricultural innovations like the reaper. Crouching in a field, looking for lantern light in a barn's gable in the distance, we can imagine the terror and yet the strength of will required of those on the road to freedom. We may sometimes take for granted the barns that have become a constant part of our landscape, but learning about the history they embody helps us appreciate what we have today.

Lore

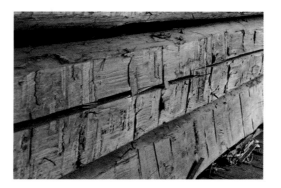

In 1833, when it was time to harvest wheat, farmers typically employed people to go out into the fields, cut the wheat, drag it back to the barn, and thresh it. To thresh the wheat, the workers would beat it over something like a saw horse to knock the grain off the plants, and then they'd gather it into sacks on the floor. Barns were built with designated threshing floors to accommodate this labor-intensive harvesting activity. Meanwhile in Virginia, Cyrus McCormick was perfecting his father's invention, a machine that could thresh the wheat in the fields, acres at a time. McCormick's "reaper" was patented in 1834.

But fields in Virginia were relatively small and labor abounded. A friend suggested that McCormick travel west, where there might be a greater need for his costly and complex machine. In Chicago, McCormick found a champion for his reaper in the founding mayor of the city, William Ogden. Land in Illinois was flat, farms were large, and, at the western reaches of the United States, the state was sparsely populated. Mayor Ogden had a vision; by working together with business, he aimed to develop Chicago and the surrounding region into a prime economic force.

Ogden took an important step by investing $25,000 for McCormick to build a factory for mass producing the reaper. As history has proven, McCormick's decision to relocate to Chicago brought success for him personally, but more important, his reaper revolutionized farming techniques and solidified Illinois's place in agricultural economies.

One of the few remaining original threshing floors—a remnant of harvesting techniques before McCormick's reaper—can be seen in an old barn displayed in the Saline Creek Pioneer Village. The Aydolette family built this barn in the 1840s with grain storage on one side, livestock stalls on the other, and a threshing floor in the middle, before they could imagine the revolution in production the reaper would bring.

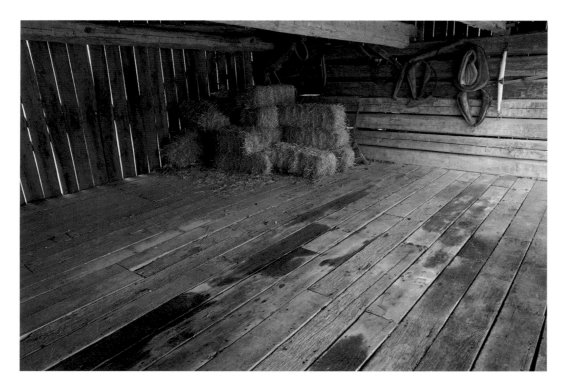

ADYOLETTE BARN
SALINE COUNTY

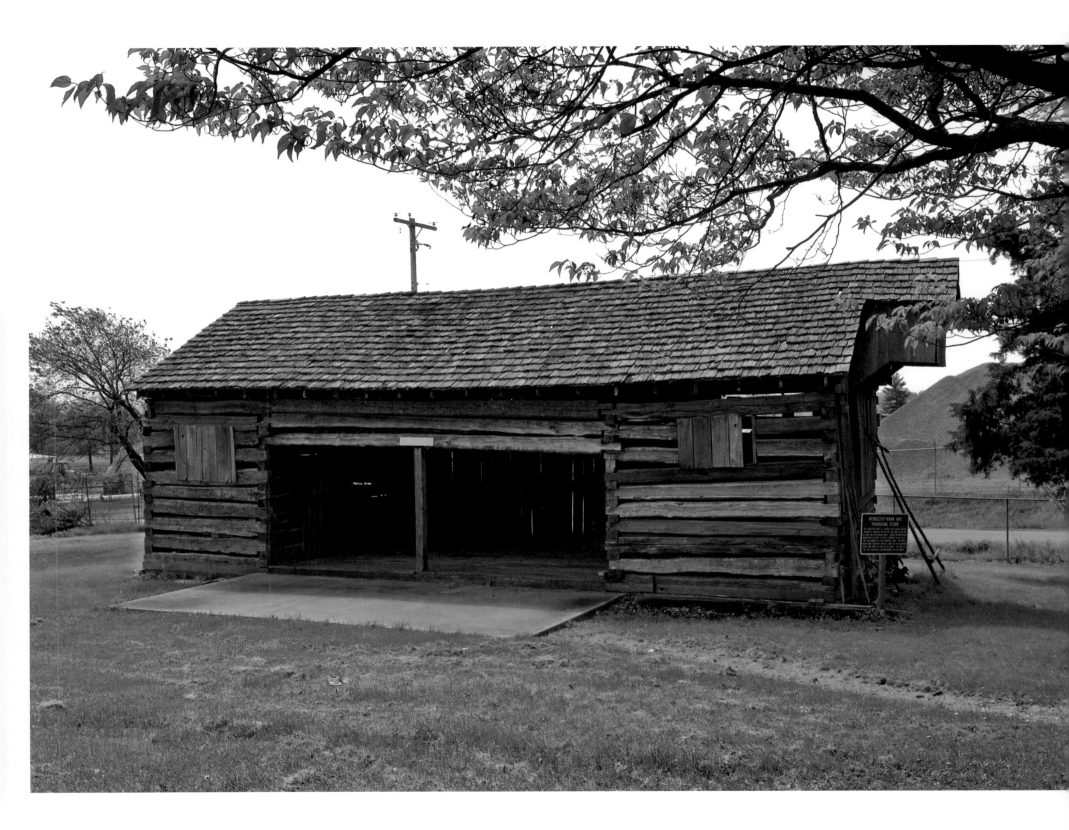

High on a hill, on the south edge of Elmwood, Illinois—population near 2,000—stands a guiding light that once signaled life or death. On an imposing three-story red barn there is a cross cut out of the gable. The Phelps barn is legendary as part of an alternate route on the Underground Railroad. Whether the cross was lit signaled if it was safe for freedom seekers to proceed to the next stop toward a new life.

PHELPS BARN
PEORIA COUNTY

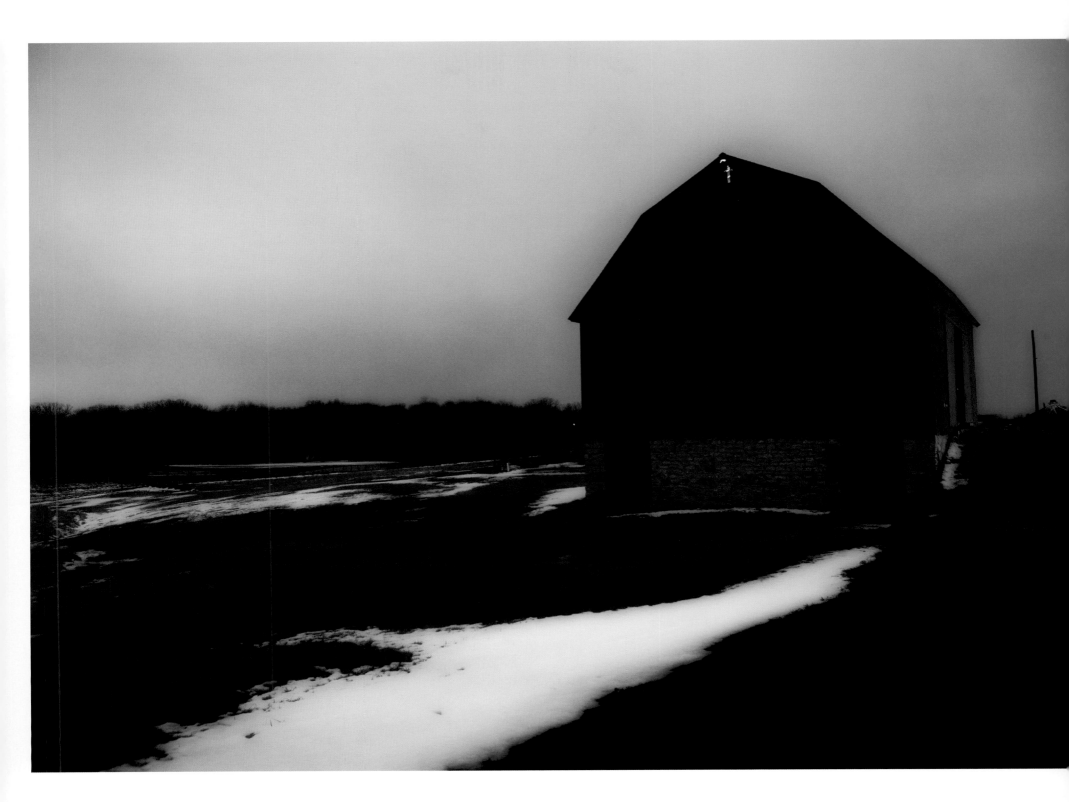

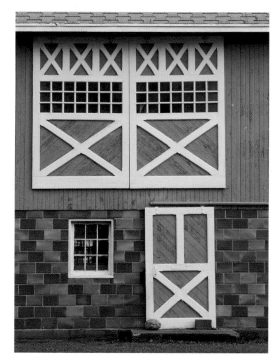

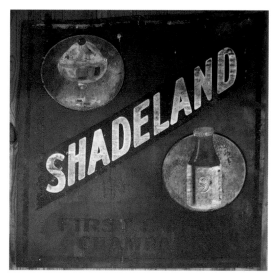

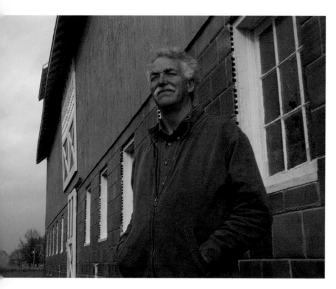

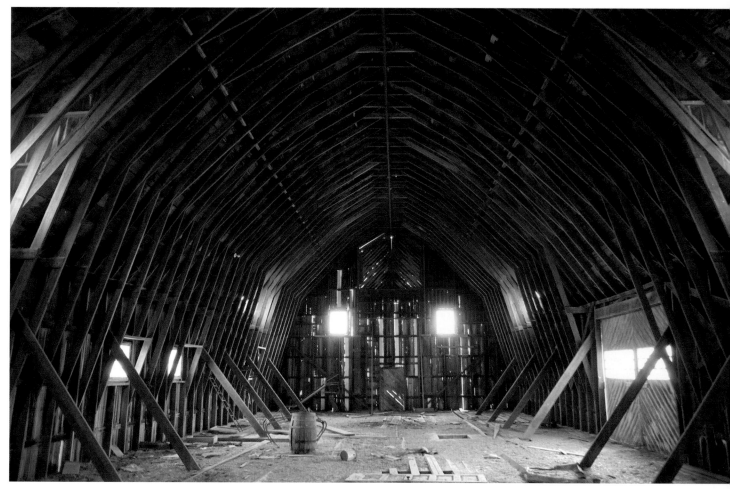

SHADELAND BARN

CHAMPAIGN COUNTY

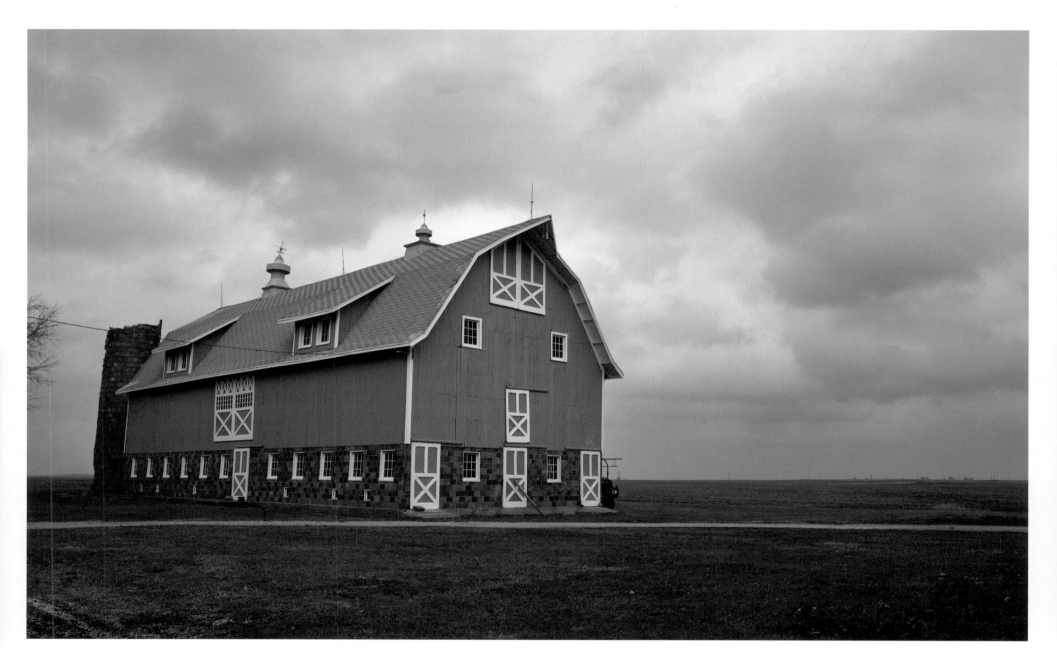

This family farm was founded by John Thornburn, a Civil War veteran. In 1891, it was said in *Pioneers of Champaign County* that Thornburn was "outspoken and radical in his political views and has fought the battles of his (Republican) party with courage and fidelity. . . . He helped to lay out about all the roads and built about all the bridges in the township. He now has a fine farm of 250 acres and knows how to enjoy life. He has no mortgages or debts to annoy him, and he is about as happy and prosperous as any man could be." Today the land is farmed by two brothers, Roger and Gary Grace, descended on their mother's side from H. R. Shade, who bought the land from Thornburn. The brothers' father, Lyle, himself a veteran, took over the farm when he returned from World War II.

In 1925, the Shadeland Barn gained notoriety in agricultural history. The Shadeland Barn's Holstein cow, Pauline America Shadford, was the world's record holder for combined yearly milk and butterfat production. That was 13 tons of milk, containing 1,164 pounds of butter fat. Occupying a proud place in local and agricultural history, the Shadeland Barn is beautifully maintained to this day.

ROUND BARNS

CHAMPAIGN COUNTY

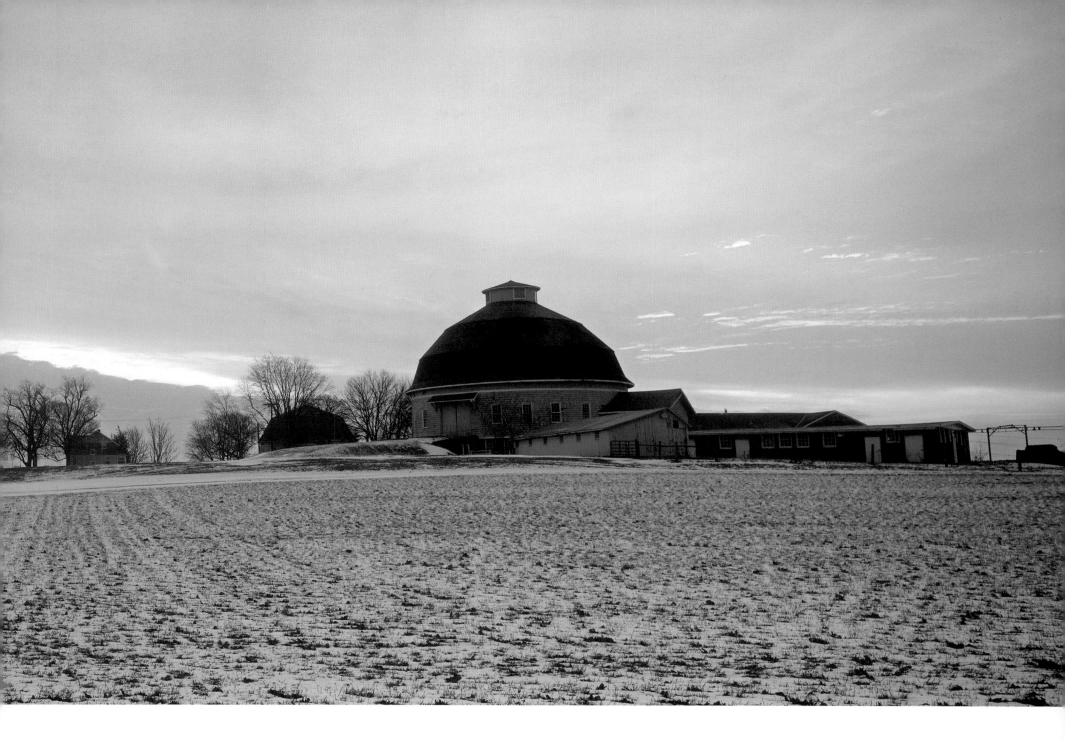

The first true round barn in the United States was built in Massachusetts around 1824 by the Shakers. It is said that the Shakers preferred round barns so evil spirits could not hide in the corners. The earliest recorded multisided or polygonal barn in the country belonged to our first president. George Washington built a sixteen-sided barn in 1792.

The University of Illinois at Urbana-Champaign was instrumental in popularizing the round barn throughout Illinois and the Midwest, in part by publishing a booklet in 1910 entitled *The Economy of the Round Barn*. It advised putting a silo in the middle to help support the roof. The university also built two demonstration round barns, in 1907–8 and 1910. Its

investigations showed that the circular structure is much stronger than other forms; that the rectangular form required 22 percent more wall structure and foundation to enclose the same amount of space as the round barn; and that the cost of materials was from 34 to 58 percent greater for the rectangular building.

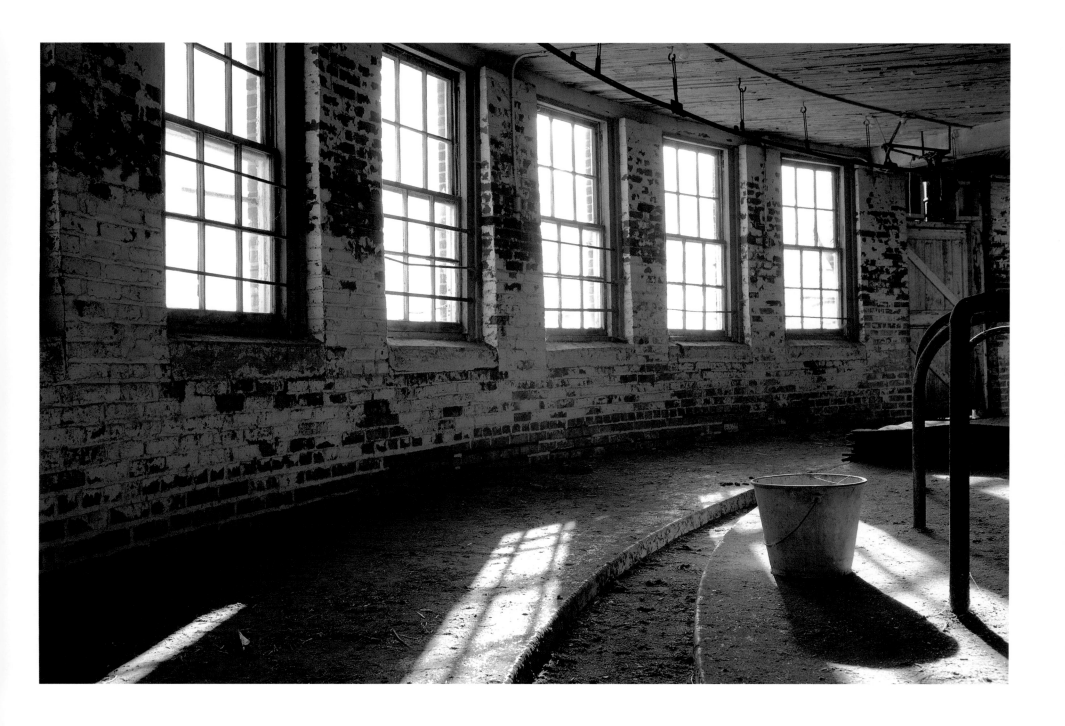

ROUND BARNS
CHAMPAIGN COUNTY

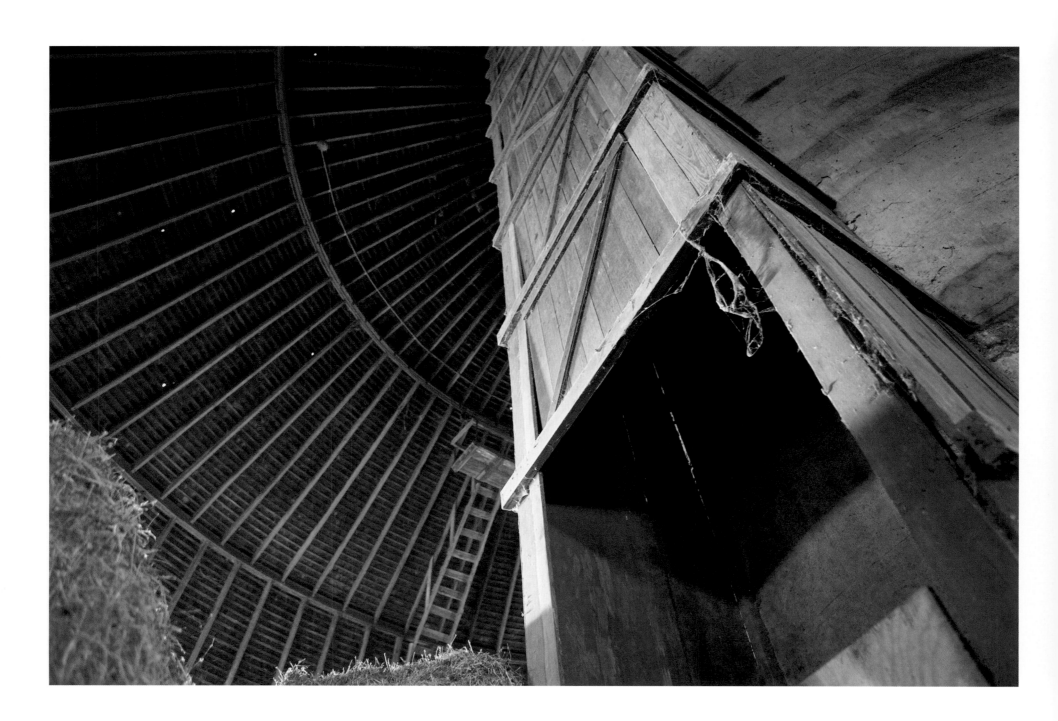

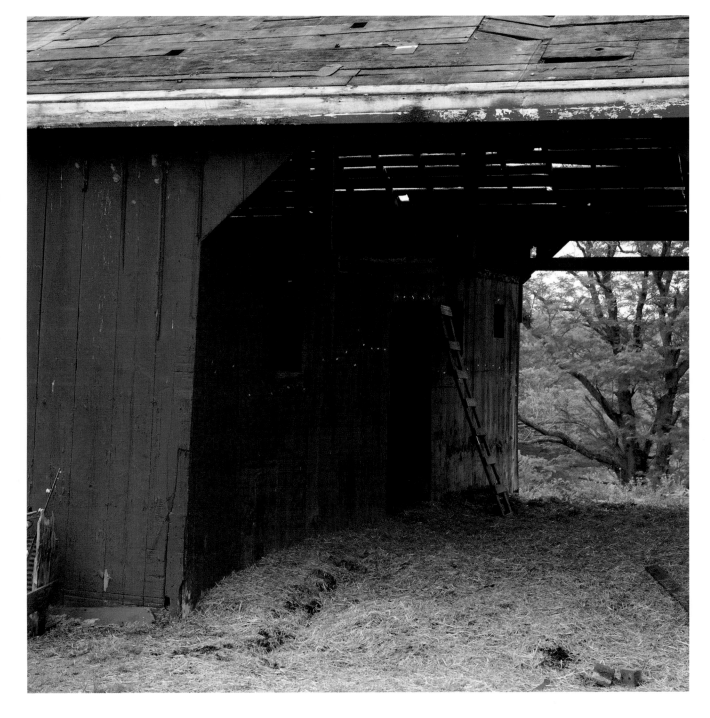

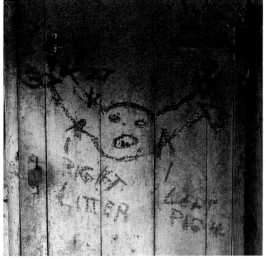

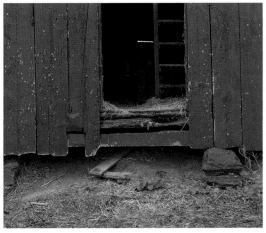

Barns are not just places where things happen over the years. They communicate. Some even pass down traditions on their very walls. Detailed sketches inscribed on an interior door of the Gindler barn preserve the family's prescription for how to trim pigs' ears, their system for remembering which sow was a particular pig's mother, and the record of a piglet's birth order in the litter.

GINDLER BARN
MADISON COUNTY

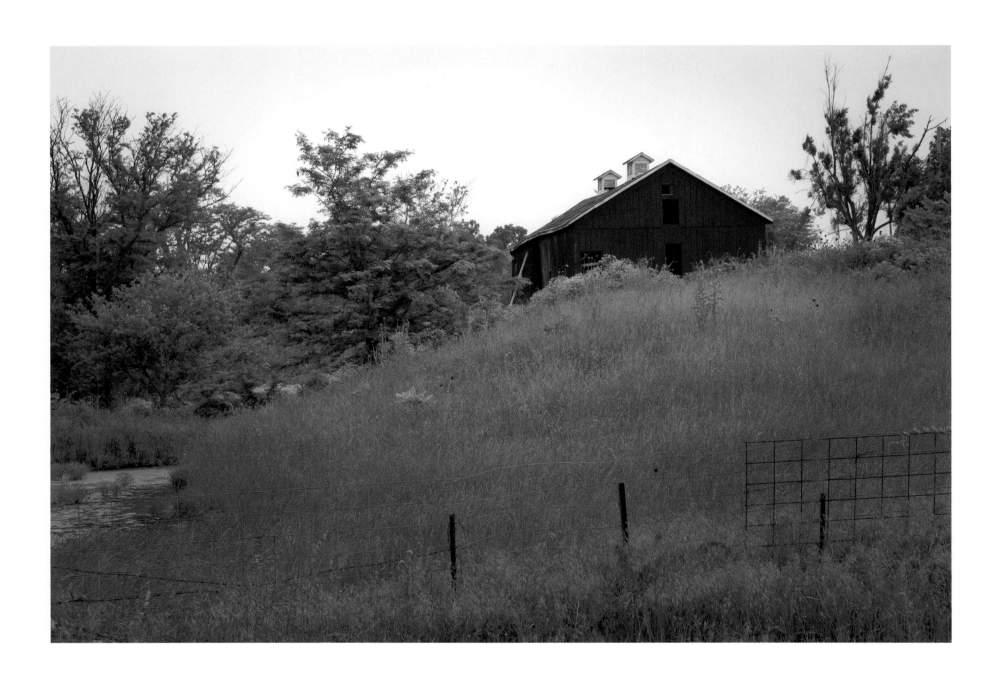

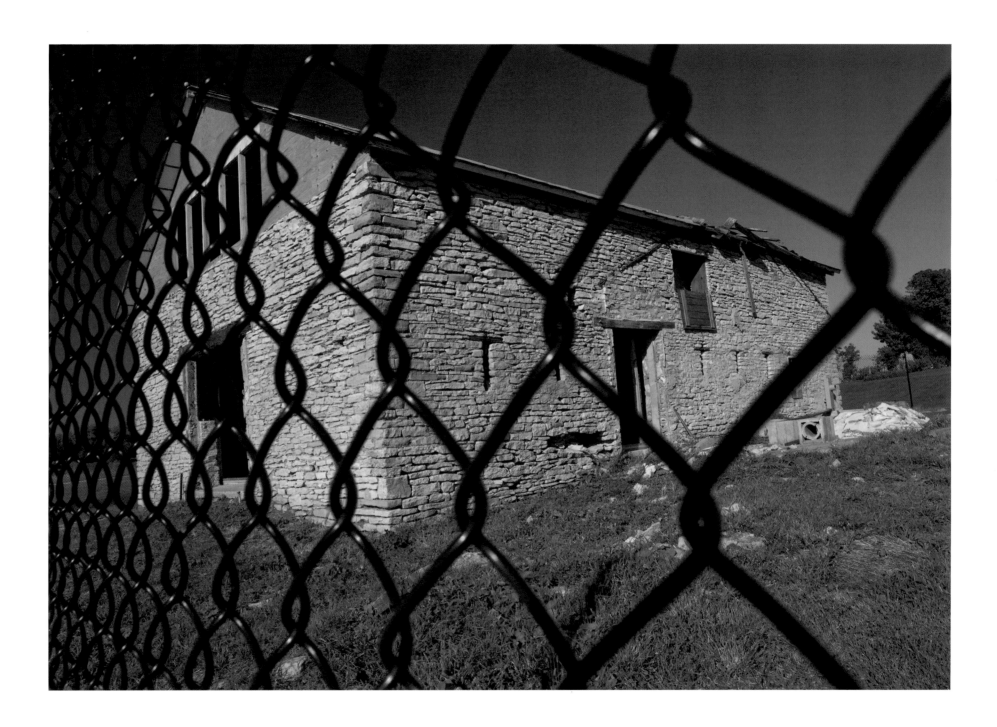

Many rich historical legends converge at the site of one lone barn in Oswego. Now surrounded by mega-mansions, the Henneberry stone barn—built before the 1850s—has been described as a classic English barn. Archaeological surveys have yielded evidence of occupation on this site by seven different Native American cultures dating back ten thousand years. In the nineteenth century, the Townsend family purchased—in order to free—the only slave ever auctioned in Kendall County. Early models of the McCormick harvester were manufactured by the same Townsend family on this site, under contract with Cyrus McCormick. Today, the interior of the barn is being renovated to give it new life.

From the white-on-white embossed
landscape of winter to the sudden gush
of spring storms, from the heavy, humid
days of summer to the energetic impera-
tive of fall, barns endure throughout
the seasons. Barns provide shelter for
livestock, hay, and machinery—the liveli-
hood of farmers. Barns provide farm
children with a place to play. Barns are
rallying points for people at community
events. Barns bear witness to the end of
the life cycle. When we see a barn standing
strong, built to weather the seasons, we
remember that every day, every month,
every year, we depend on them.

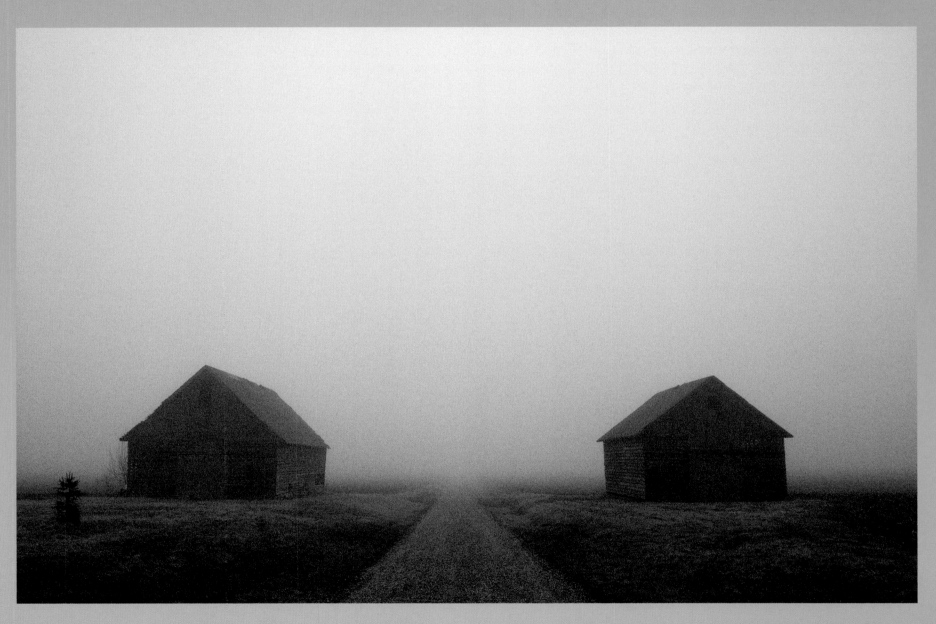

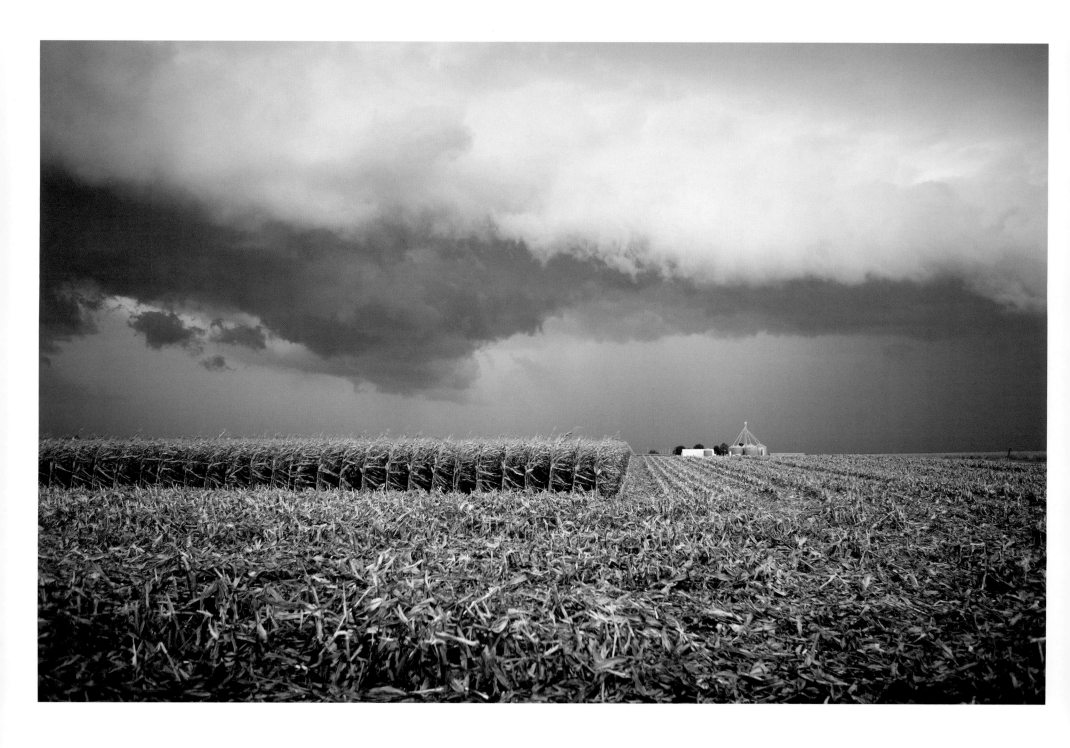

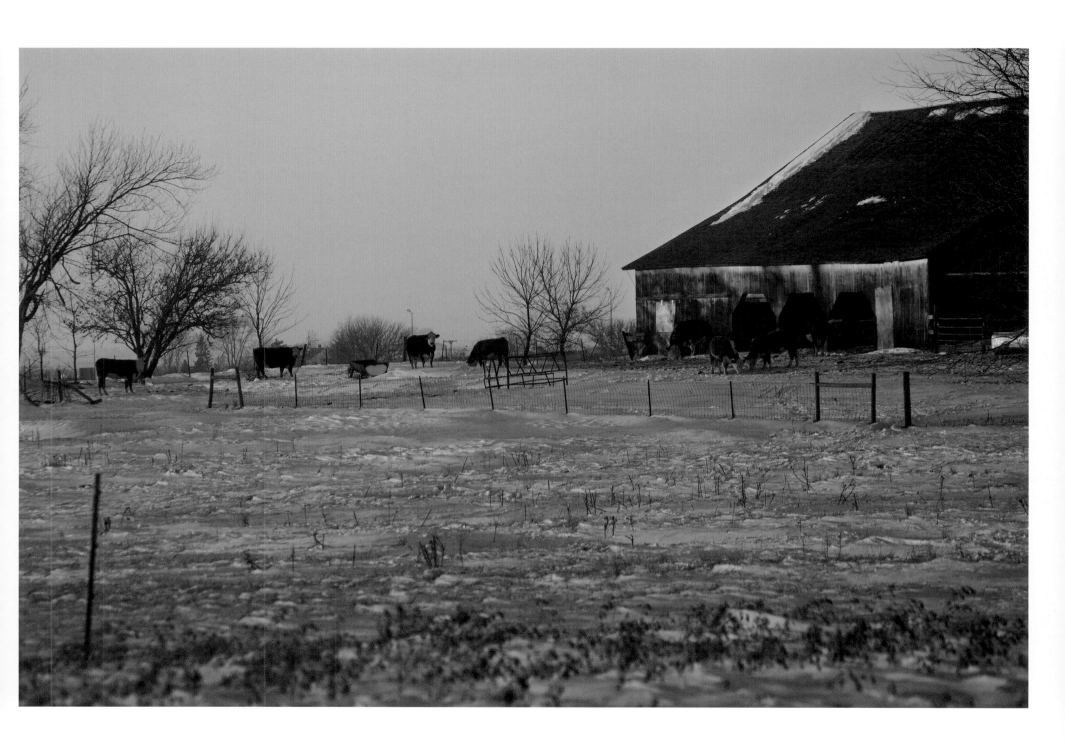

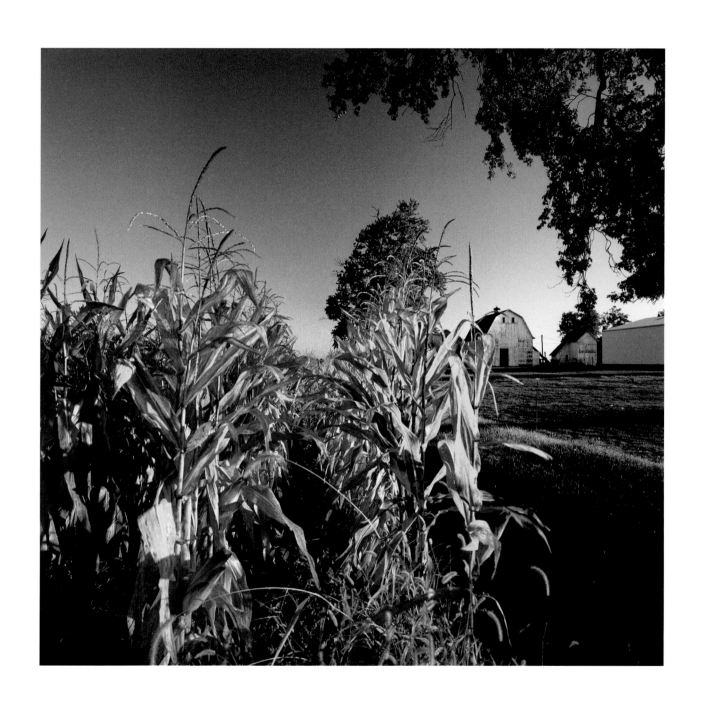

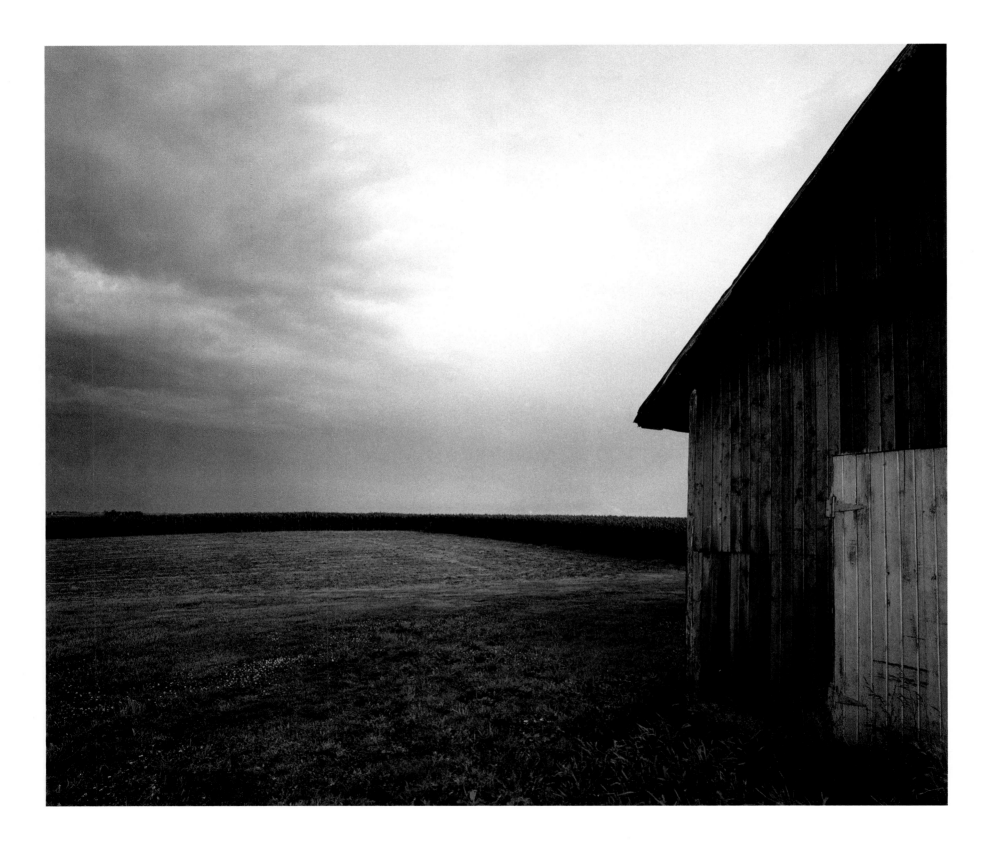

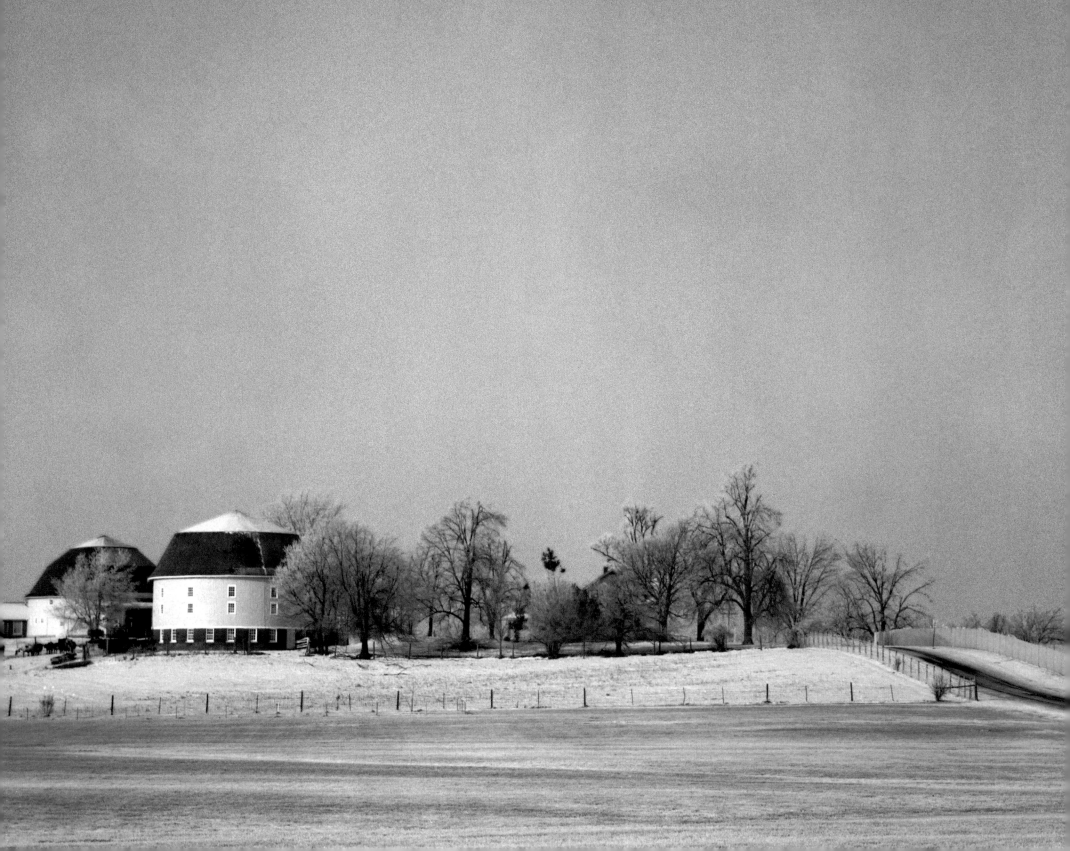

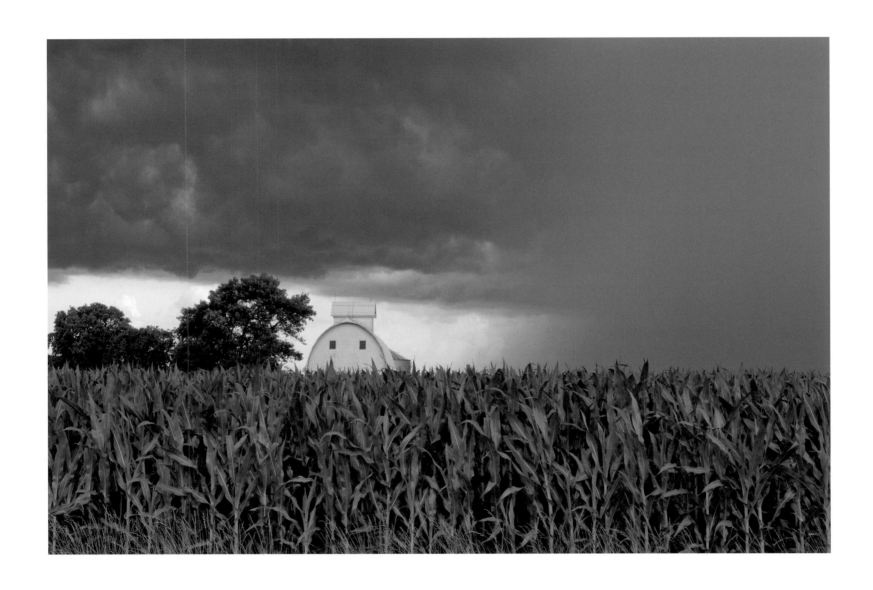

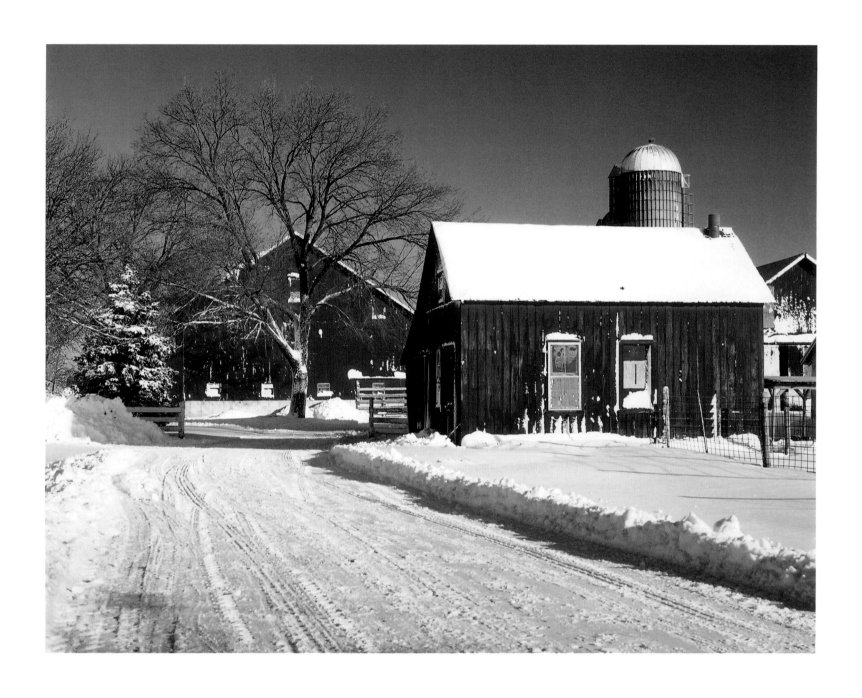

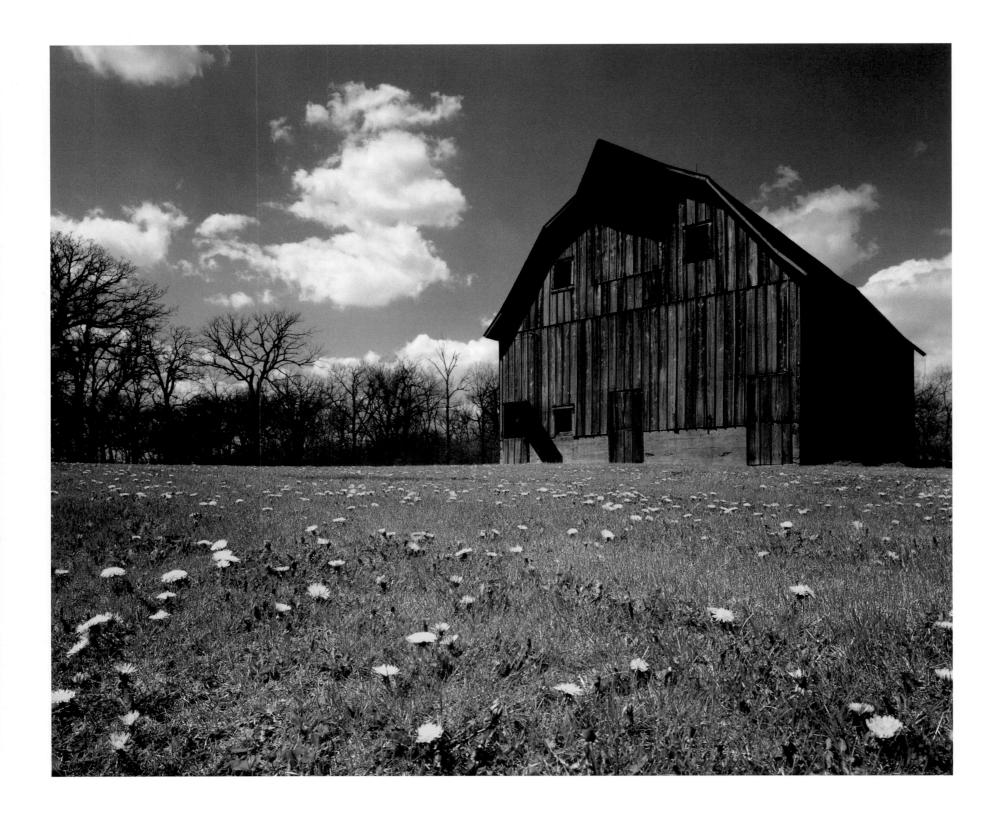

Throughout the Midwest the flat, fertile landscape is punctuated by vestiges of civilization—barns. Each barn has its own character and makes a distinctive imprint on the land and on the lives of those who pass by. We are delighted when we see a familiar barn on a seemingly unending continuum of empty land. Then we know we can find our way. When we understand architectural trends, new barns we encounter are no longer strangers. With a spark of recognition we exclaim, "That's a Sears barn" or "That's got to be a Newt Willis barn!"

A barn can take us back to a place in our minds that is comforting, or it can bring us together to a meeting place. In vast, open space and in fast-changing times, barns are anchors for us, revered for their landmark status: directional, architectural, emotional, or cultural.

Landmarks

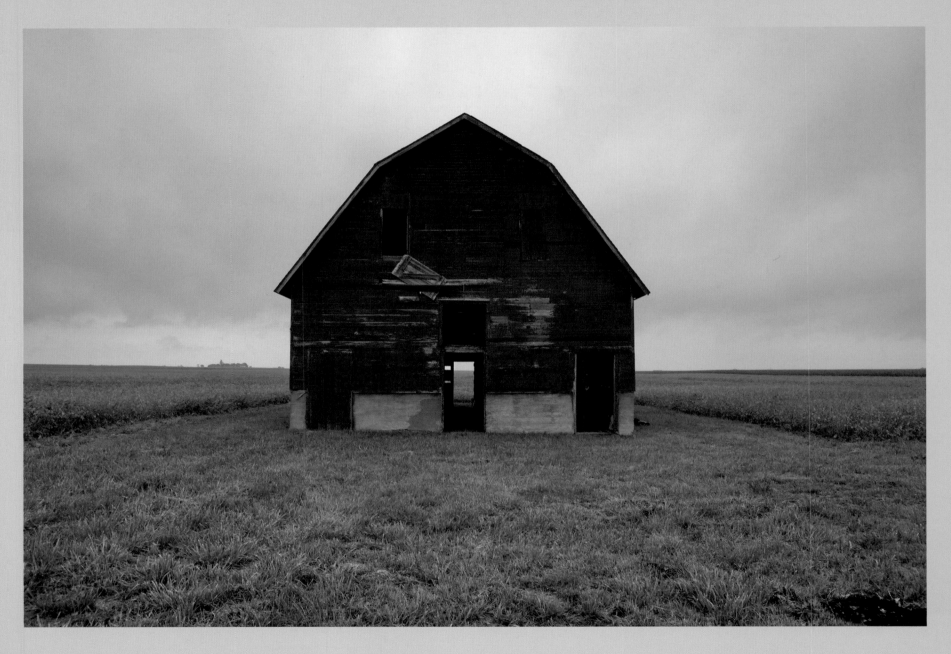

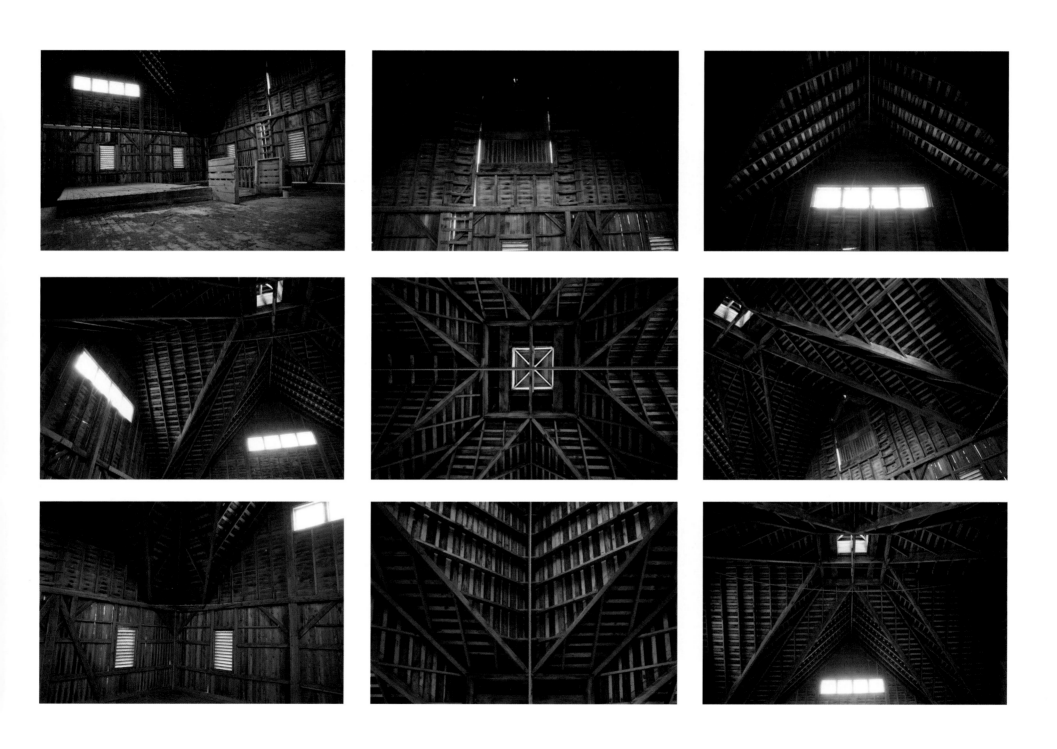

NEWT WILLIS BARNS

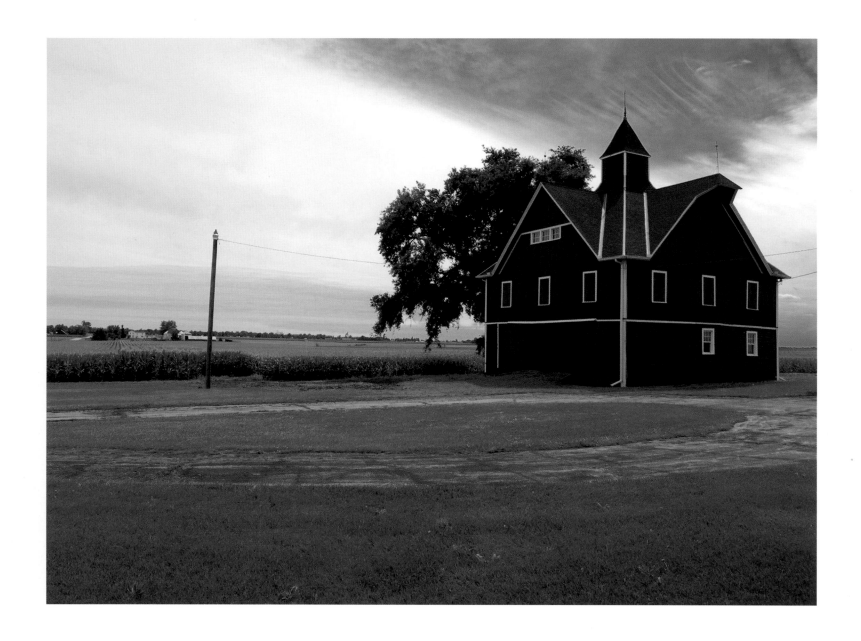

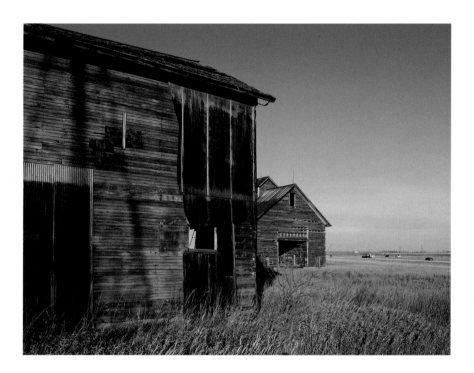

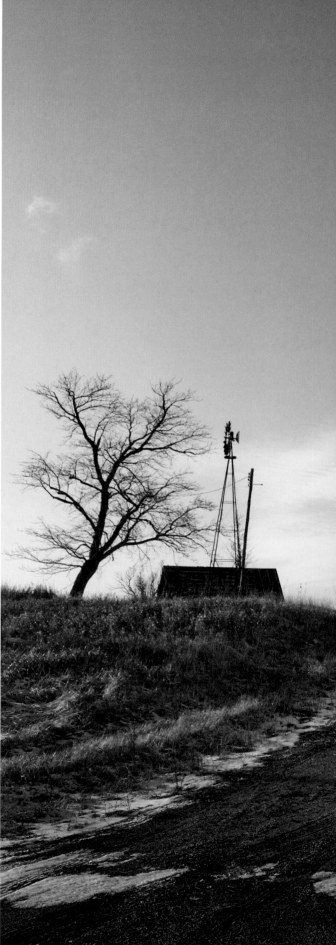

Barns that are visible from the highways provide benchmarks for our travels and become friends along our journey. It wasn't surprising when a woman who travels extensively by car commissioned a photographic study of one particular barn. She did not know who owned the barn. She did not know the history of the barn. But she could perfectly describe its exact location and the details of how the barn looked in each different season. She explained, "I pass this barn every time I drive on Interstate 55. I just love this barn, and I'm afraid one day it won't be there."

ANONYMOUS BARN
LIVINGSTON COUNTY

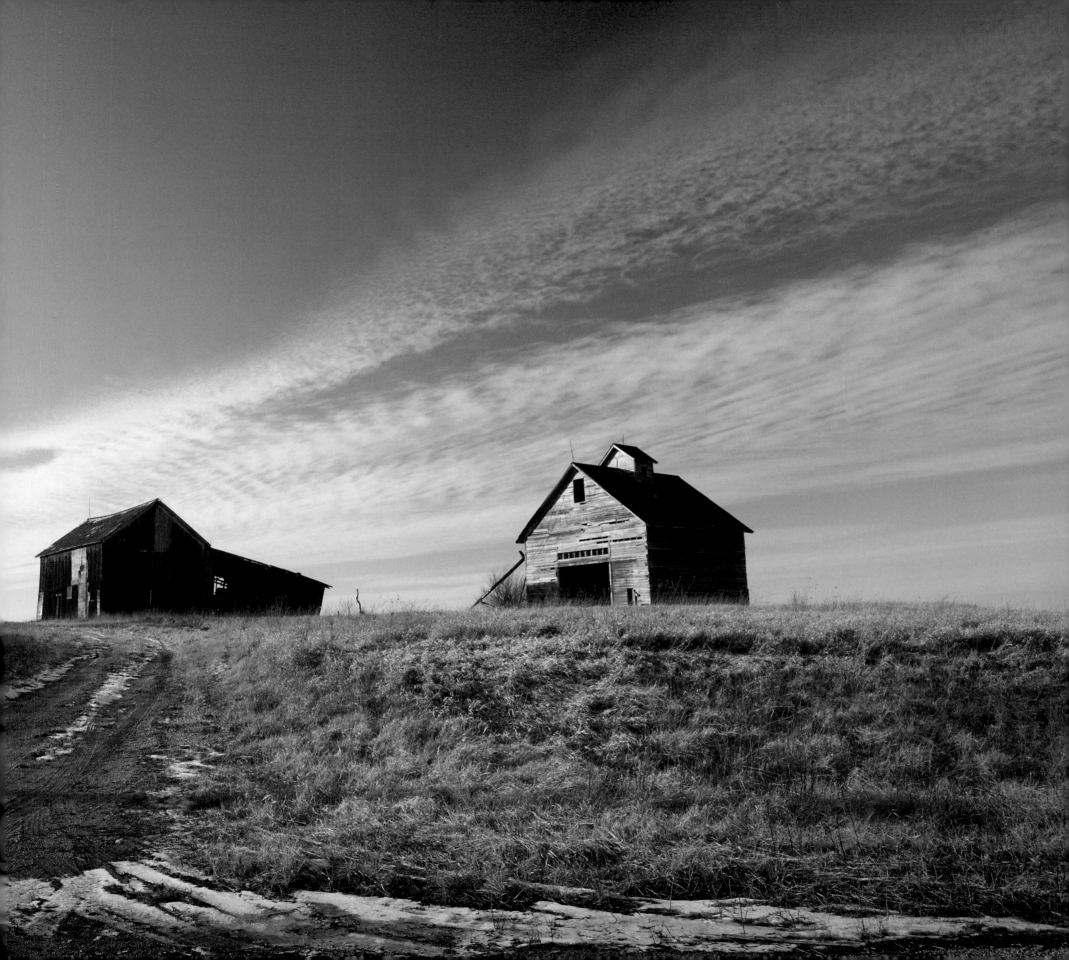

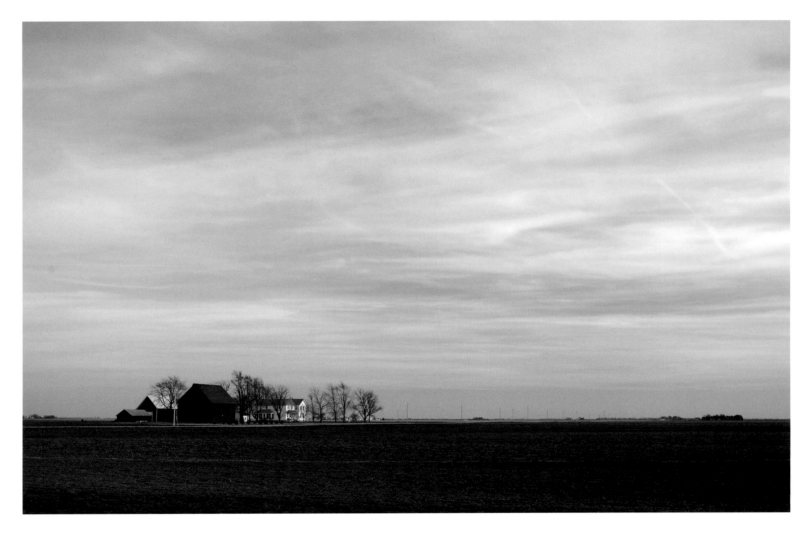

When the Chandlers purchased the farm in the 1990s, they created a holiday tradition of hanging a large, welcoming wreath on the west side of their red barn. Sparkling in a spotlight, the wreath on the red barn became a landmark for all those rounding the bend in the road outside Buckley each Christmas season. The farm has since been sold. It is no longer in the family and the barn no longer displays a holiday wreath. But the barn remains an emotional landmark. Now when people in the Chandler family drive by, the red barn on the horizon reminds them of playing barn ball in the hayloft, baby pigs, and holiday wreaths, all etched indelibly on their hearts.

CHANDLER BARN

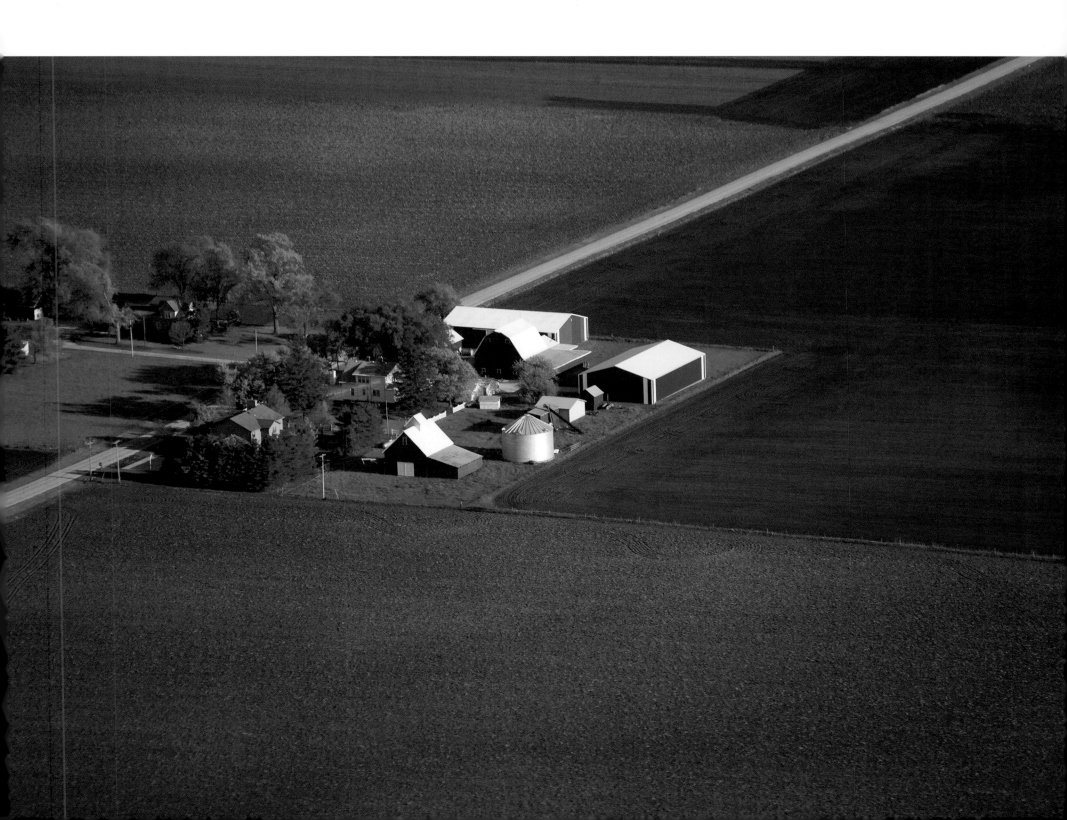

Some regions of the country have mountains that carve up the horizon, or a rocky coastline with steep contrasts that express an obvious beauty. In the Midwest, barns create their own aesthetic. Providing visual interest with their subtle details, the structures trace a geometry on the horizon that challenges our senses. We must consider a level of abstraction and look beneath the surface to discover the subtleties and appreciate the beauty in the patterns. Whether viewed from the road or from the air, the repetition of forms and patterns, similarities and differences, and varying scales create their own composition on our midwestern landscape.

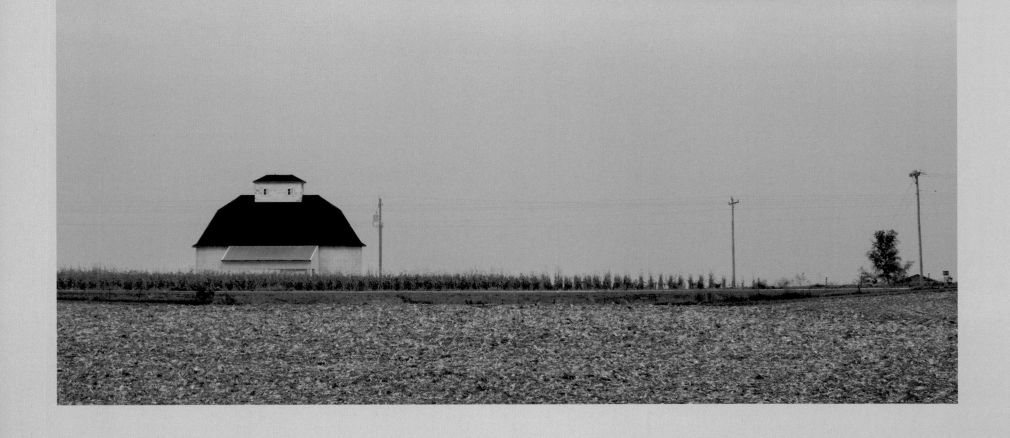

Geometry

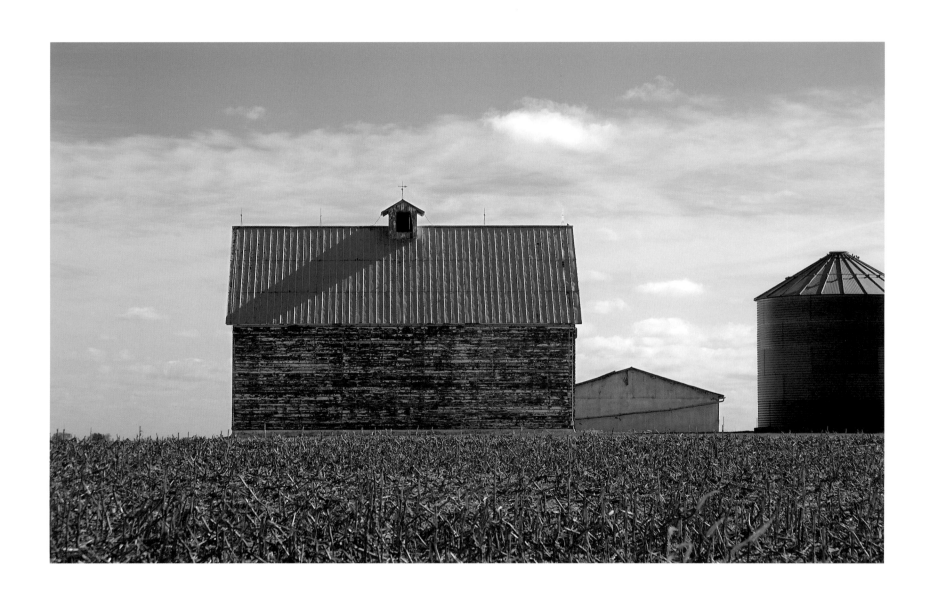

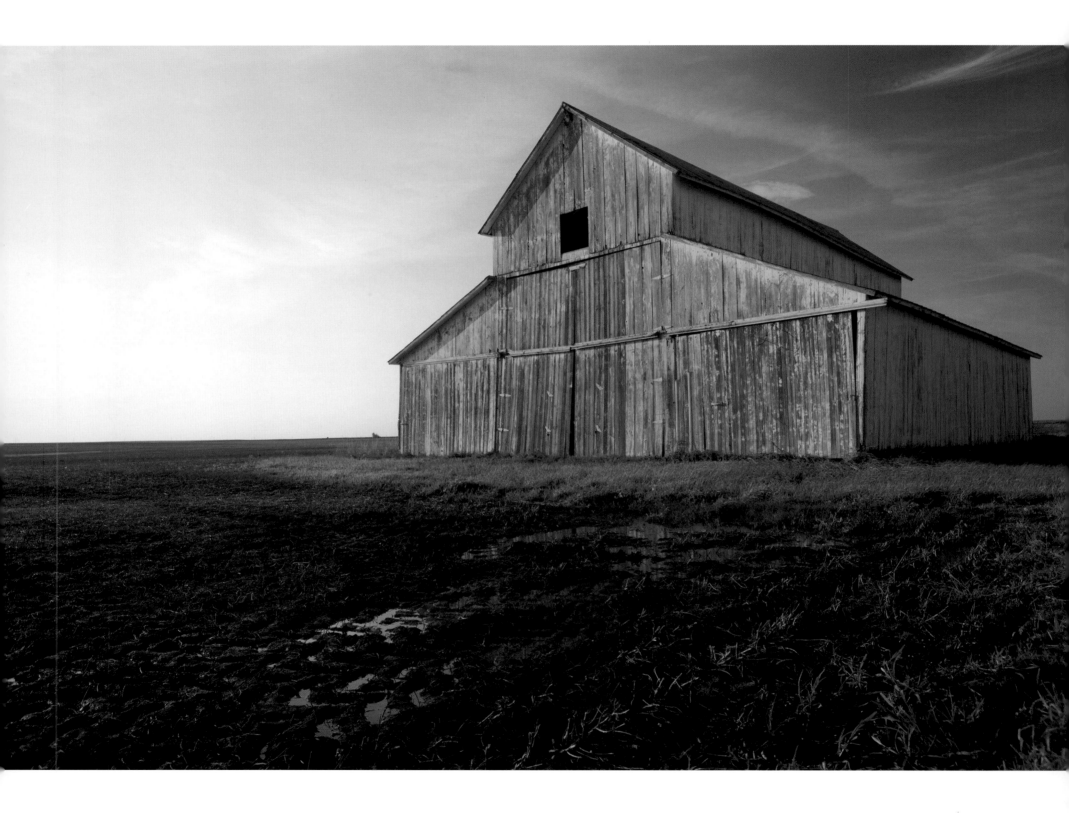

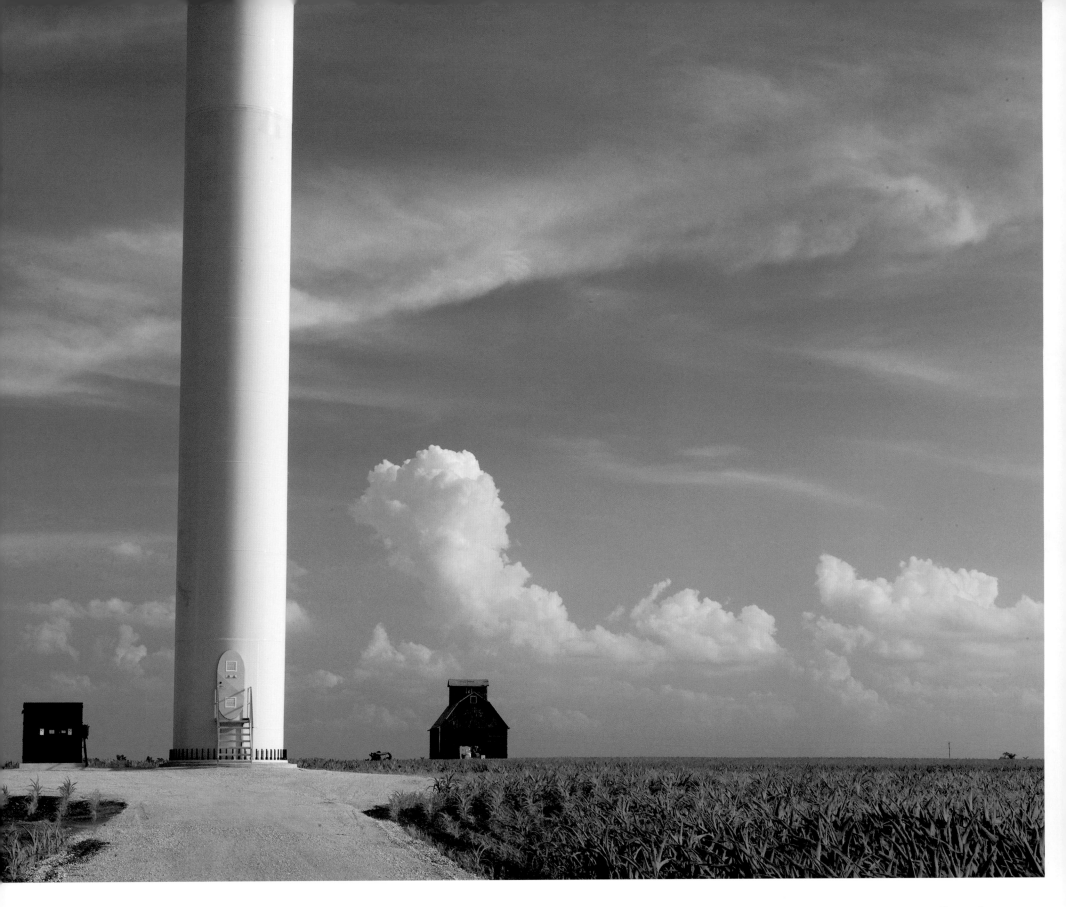

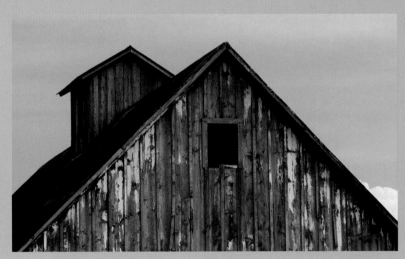

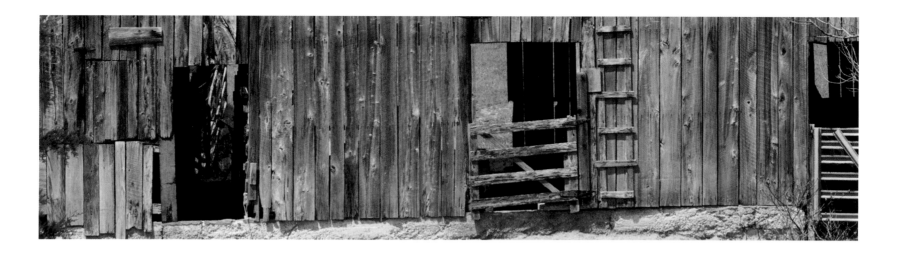

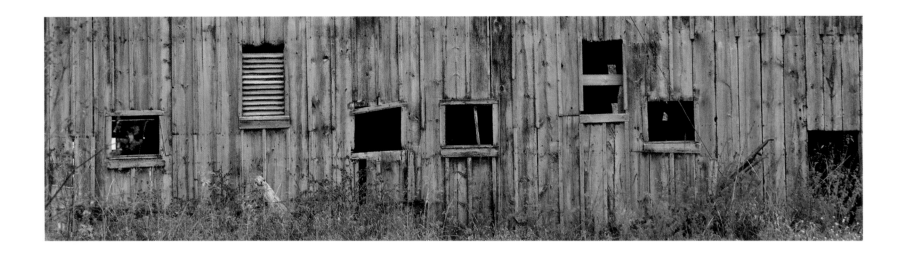

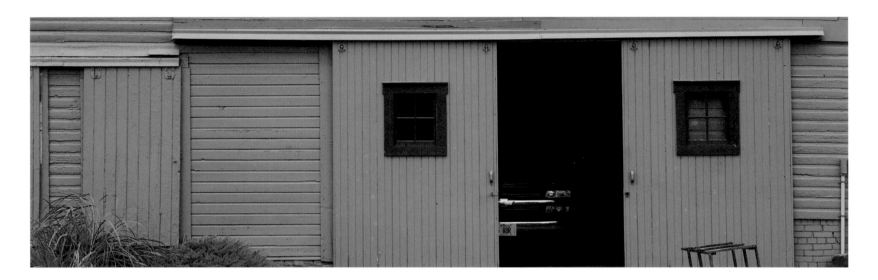

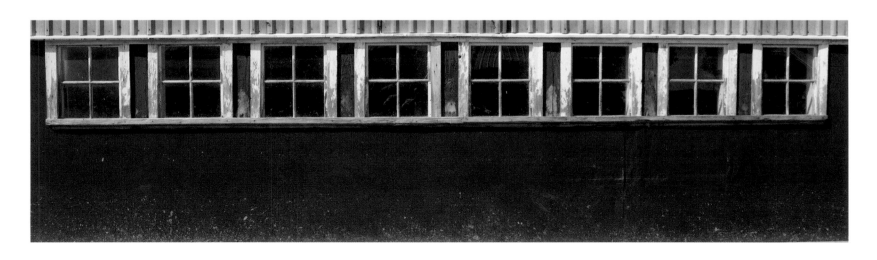

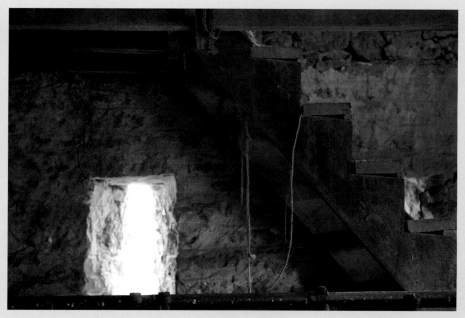
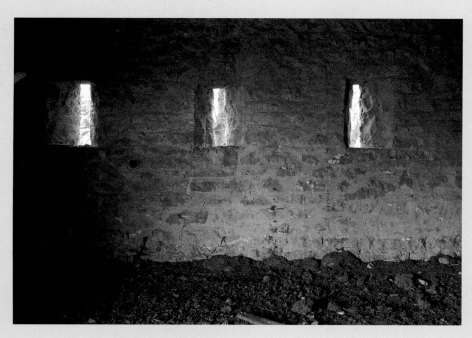
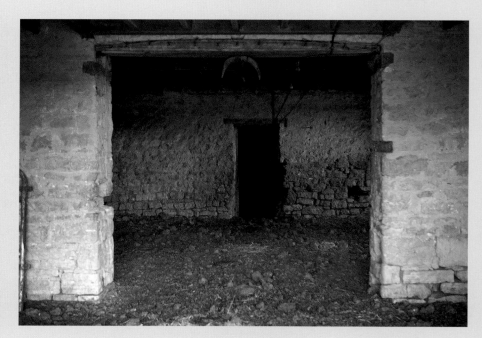

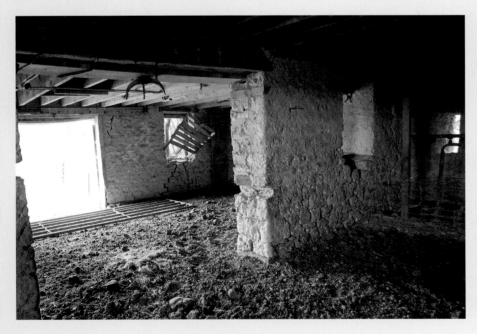

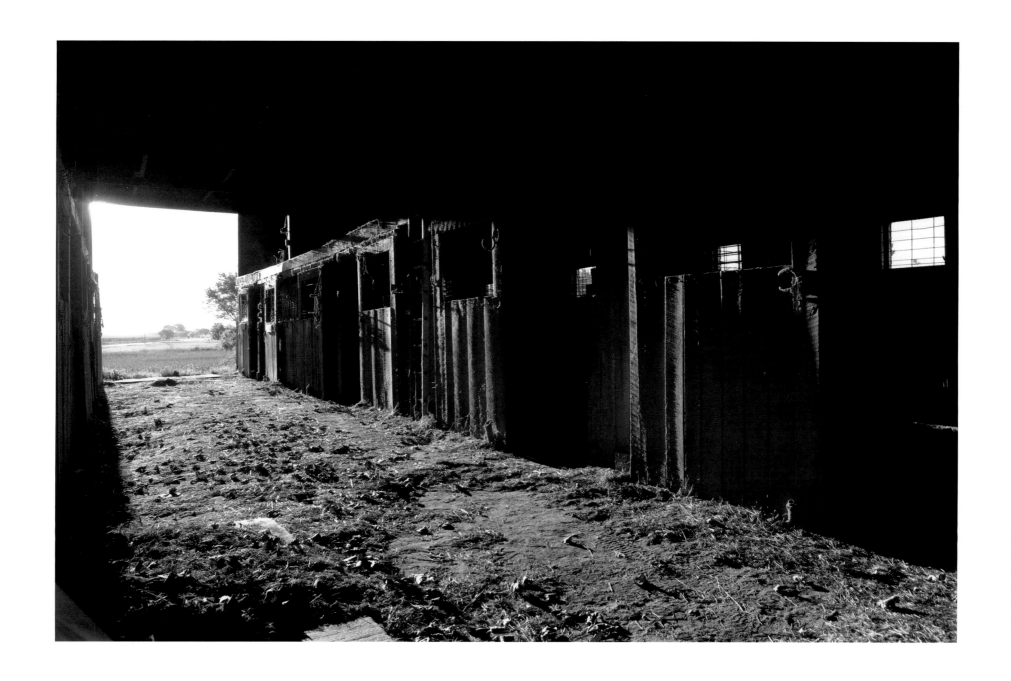

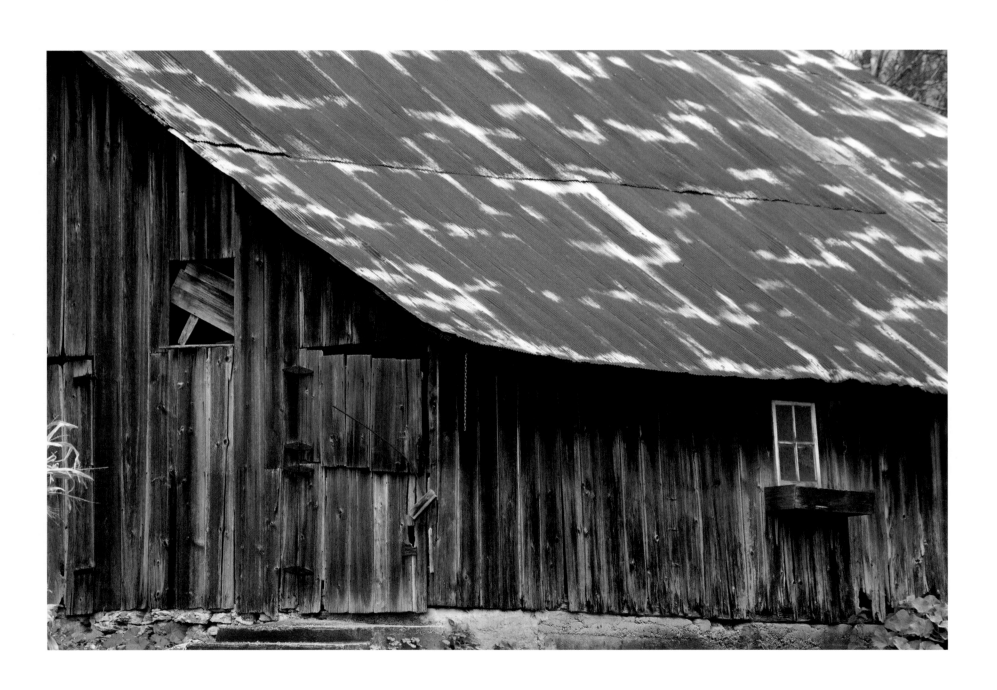

Sometimes the future of barns seems bleak. Many estimates put the number of barns in Illinois today at less than one-third the number that existed a hundred years ago. What is happening to these barns? Some just wither away. Some are torn down because they are too expensive to maintain. Others are lovingly dismantled and moved, in hopes that they can be used again some day. But all is not lost. Every alarming statistic about the demise of barns is offset by the activities of organizations of barn enthusiasts. Barn keepers, barn tours, the Illinois Barn Alliance, groups of children, and others are recognizing, celebrating, and embracing the historic barn.

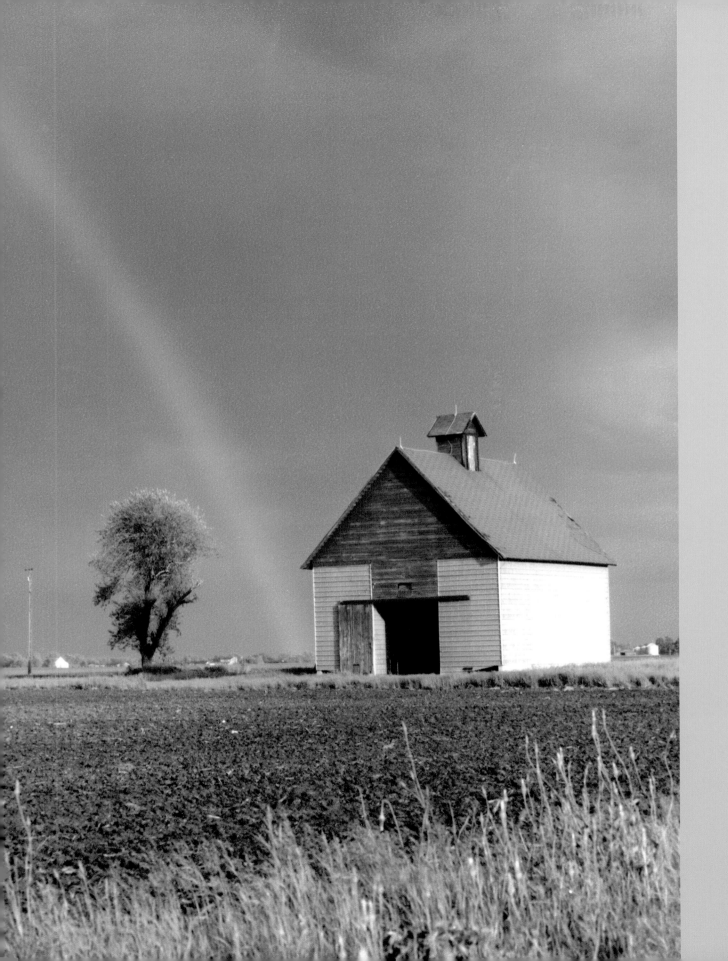

Fate

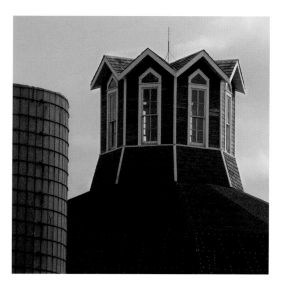

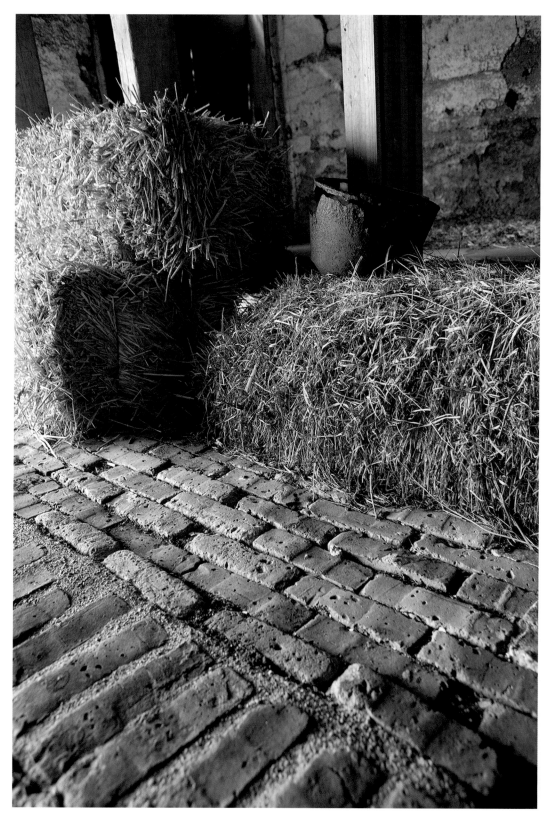

TEEPLE BARN

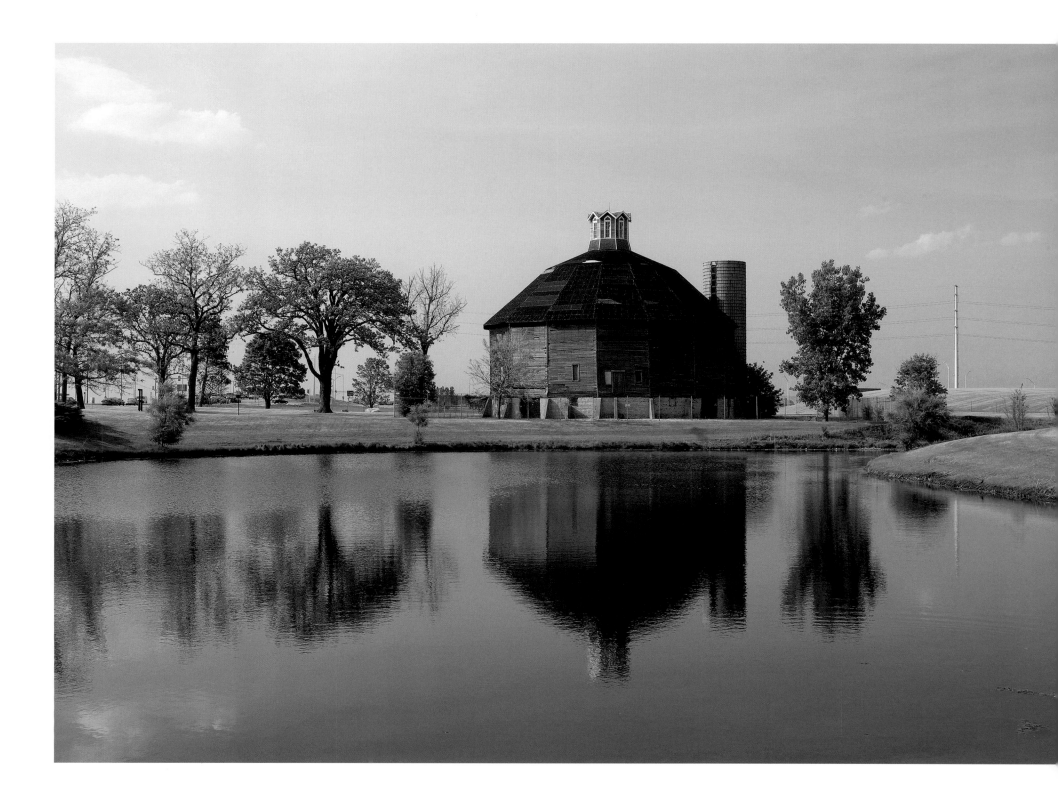

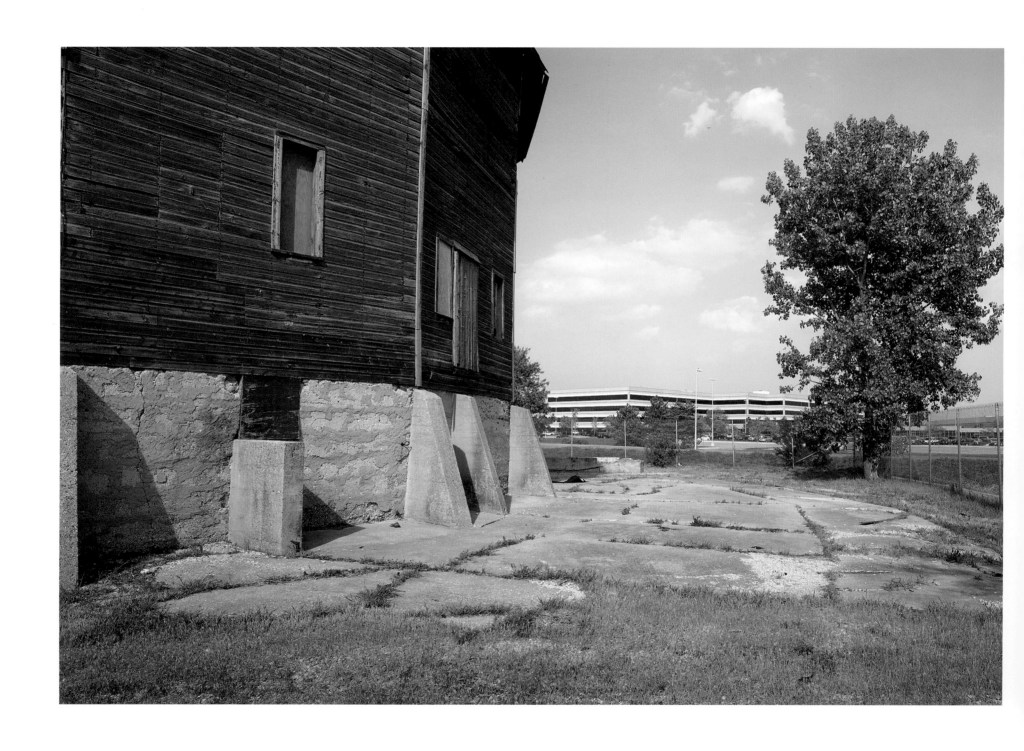

TEEPLE BARN

KANE COUNTY

In 1885 Lester Teeple built a sixteen-sided barn that was later listed on the National Register of Historic Places. As suburban Elgin grew around it, the Teeple barn seemed more and more out of place. Commenting on the unusual construction that used very long planks of wood instead of two shorter planks, Lester's great-grandson Ken noted how remarkable it was that the barn had withstood the test of time. Not for much longer though. Less than one week after this barn was photographed, the Teeple barn collapsed under heavy winds. News of its demise quickly spread across the region. Barn lovers were saddened, and Ken Teeple said it was like losing a member of the family.

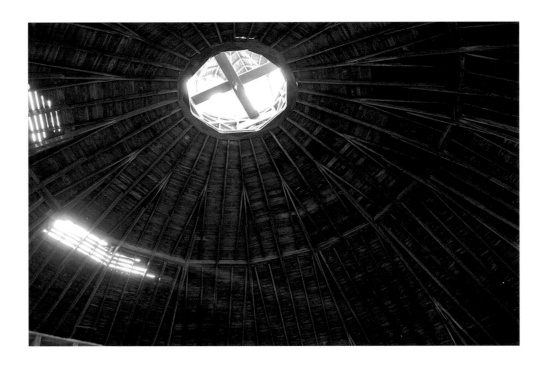

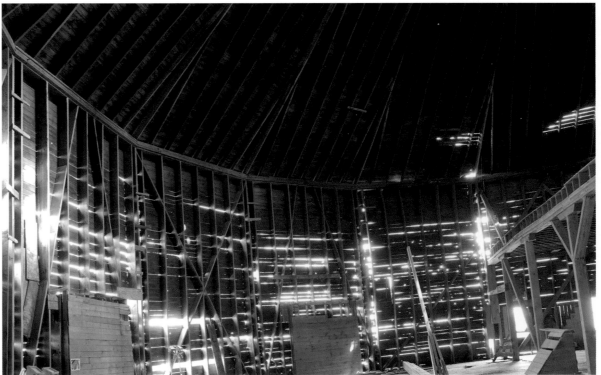

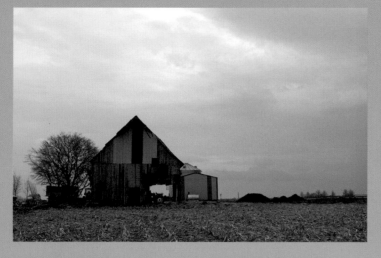
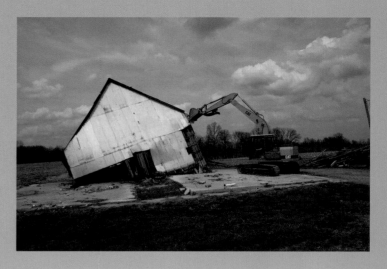
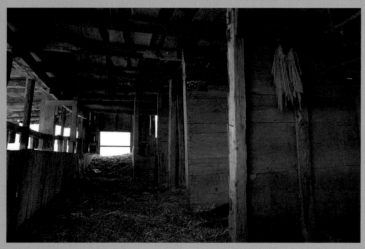
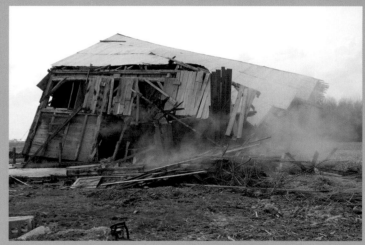
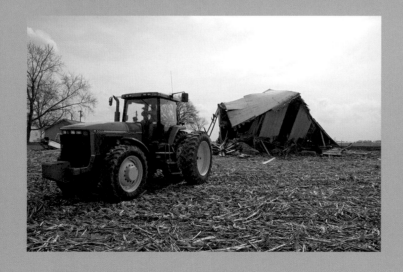
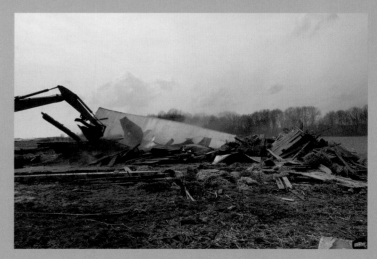

When Brett and Julie Williamson bought their farm in 1982, it came with an old barn. Built around 1889, the barn was constructed with wooden pegs and hand-cut wood. Some of the beams still had bark on them. Legend had it that gravestones from the 1850s cemetery nearby were used to prop up the old barn. Over time the barn grew to be like a loyal friend to the Williamsons, protecting thousands of dollars worth of hay and tools. But their loyalty was tested as they routinely had to pay to patch the barn together, and the barn was simply too small to house any of their modern farming equipment. After weeks of agonizing, they decided to tear it down. At least now the Williamsons could get to the bottom of the legend about their barn's foundation.

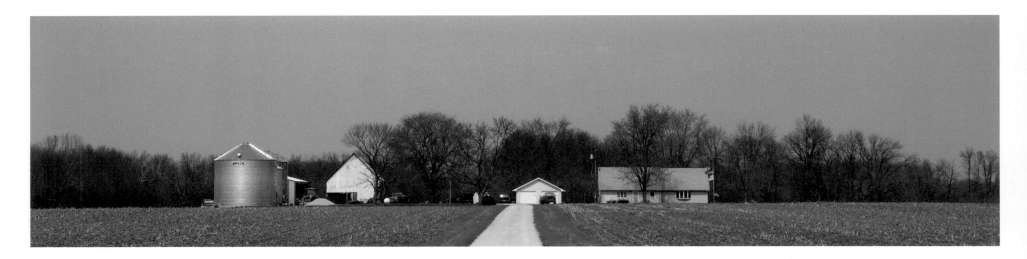

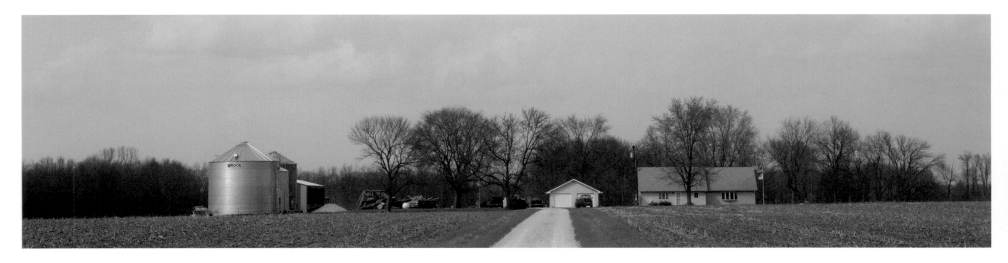

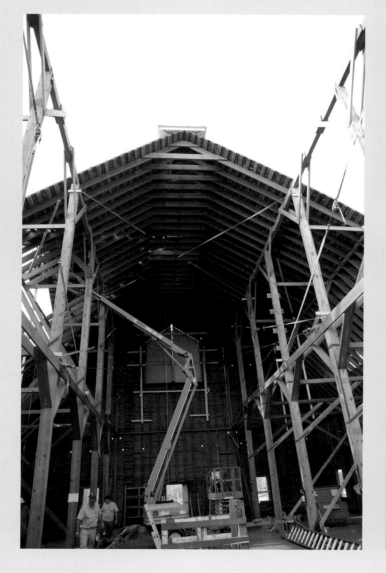

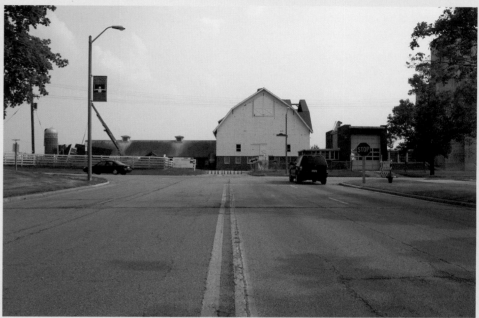

UNIVERSITY BEEF BARN/PIATT COUNTY MUSEUM
CHAMPAIGN COUNTY, PIATT COUNTY

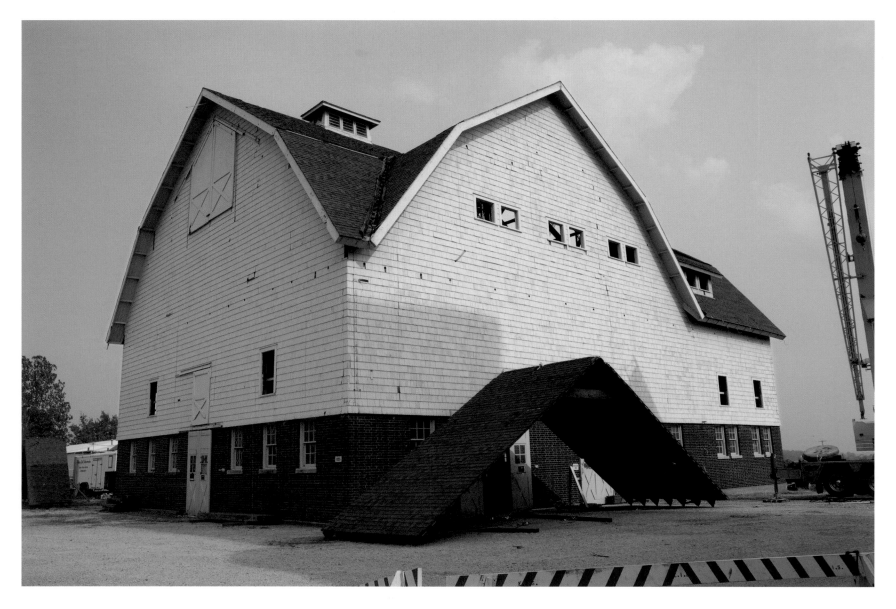

Designed by University of Illinois architecture students, the old beef barn on the UI campus was unusually sturdy. It even withstood the force of unruly college students driving into its foundation. The hay-mow floor was built out of 2 x 4 boards stacked on their sides. Rick Collins, a restoration expert, claims you could land an airplane on that stout floor. When a modern beef barn, capable of holding ten times as many cattle, was built down the street for the agricul-ture department, the university had other plans for the land where the old beef barn stood, and the old barn was put up for auction. The Piatt County Museum was the successful bidder, and in 2007 the barn was painstakingly dismantled and moved an hour away to Monticello, Illinois. The barn will be re-constructed, piece by piece, to house the new Piatt County Museum.

Sometimes a sense of personal history can change the fate of a barn. A resident of Rockford, Illinois, Tim Larson Dingus regularly passed by the Aldeen Golf Course, barely noticing a barn that was hidden among the trees on the course. One day Tim's mother remarked that it was a shame the barn was showing signs of age. It turns out Tim's grandfather had built that barn. This discovery about his personal connection to the structure inspired Tim to launch a community-wide campaign to save it, complete with news conferences, collection cans, t-shirts, and even gifts of engraved hammers for the largest donors. The campaign was a resounding success. Today the barn that Tim's grandfather built is not only a majestic icon of the golf course, but also used by golfers as a target to line up their shots—a chance for a hole-in-one.

ALDEEN BARN
WINNEBAGO COUNTY

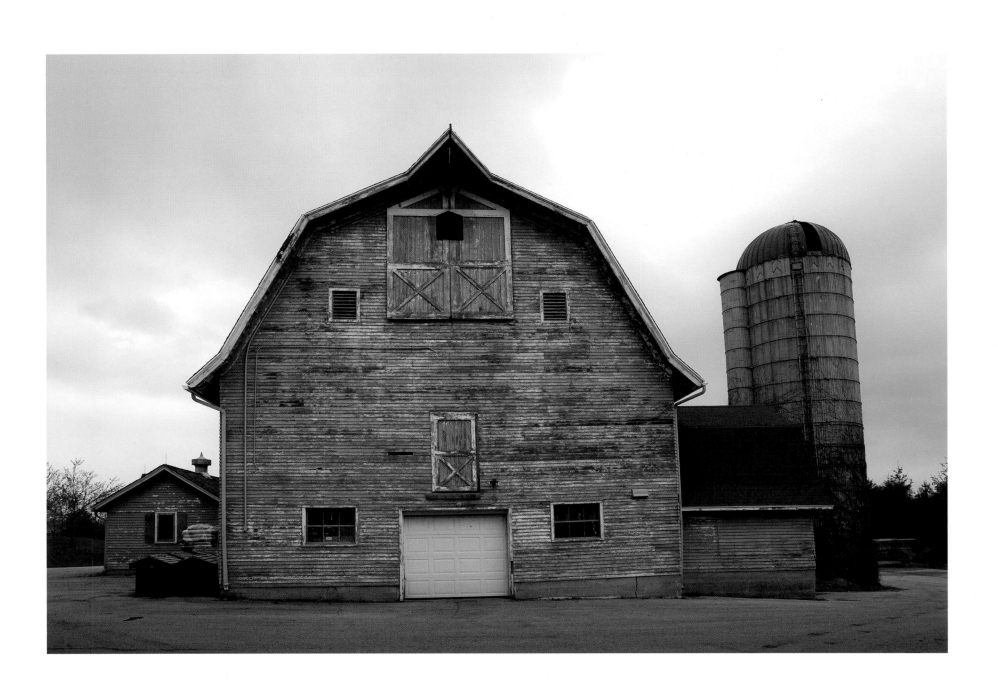

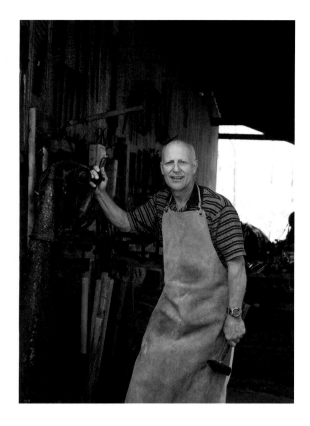

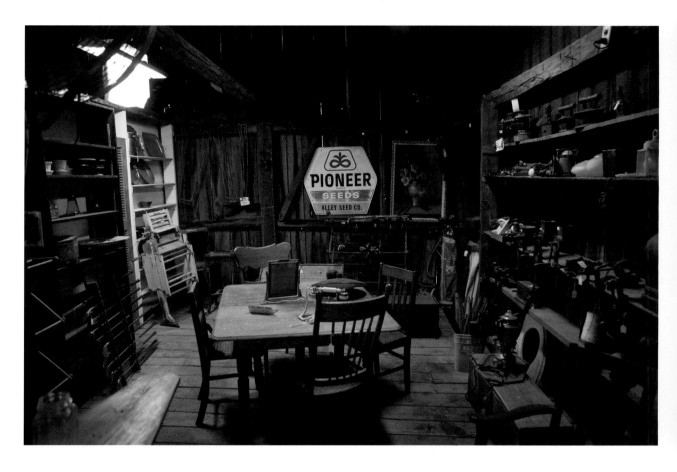

Tony Calabrese, a Chicago-area physical education teacher, used to take his high school students on rock climbing and caving trips to southern Illinois. Drawn to this rural lifestyle, he and his wife, upon retirement, drove toward Missouri to purchase farmland. But fate interceded and changed their plans, and charged the future of a barn.

The great Mississippi River flood of 1993 prevented the Calabreses from getting to Missouri. Instead they visited the Illinois cave and farmstead where Tony used to take his students. As they drove up to the property, the owner was hammering a "for sale" sign into the ground. While the location was perfect, the Calabreses declined because they could

not afford the entire four hundred acres. Returning home, they discovered a message on their answering machine. The Nature Conservancy wanted to save the cave on that same property. It was home to rare brown bats and had even sheltered Daniel Boone on occasion. The conservancy offered to split the land and the cost with the Calabreses. Today the Calabreses have a bed and breakfast—and own the barn—on the property. Tony is following his path of educating children, and the barn is now a tool to teach children the lost art of blacksmithing.

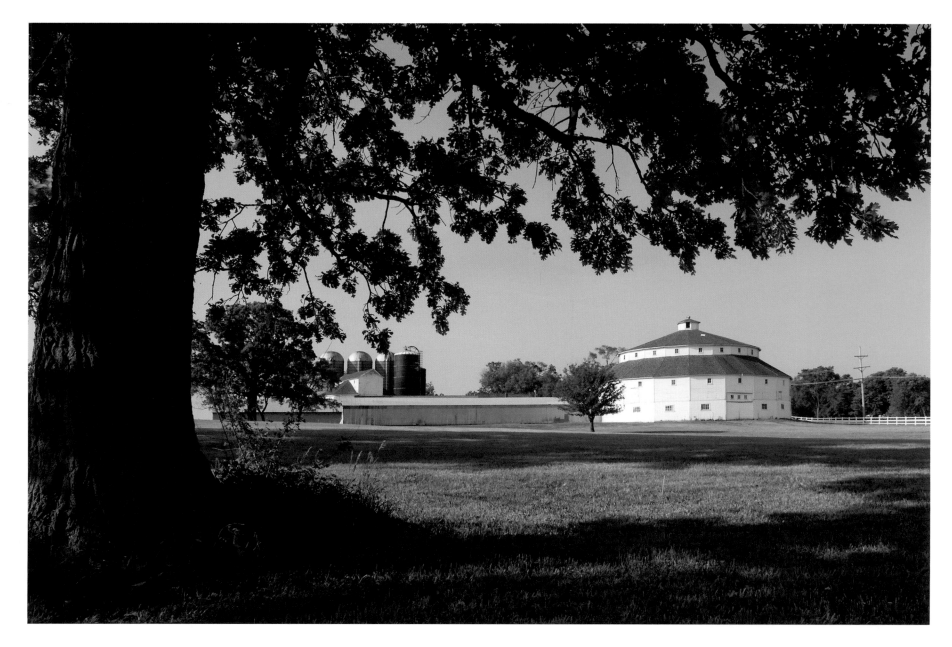

The barn built southeast of Joliet by John Baker around 1898 is legendary. With twenty-one sides and measuring a hundred feet in diameter, the impressive barn was reportedly built with lumber salvaged from the 1893 World's Columbian Exposition in Chicago. Frank Koren acquired the barn in the 1950s and maintained it well through the early 2000s. Koren worked with the local forest preserve and park district to ensure that his barn would be preserved for the future. He died one week before he was to sign the final papers transferring ownership. His children's dedication to fulfilling Koren's wishes strengthened them to hold out against the lure of developers. Then park district officials worked tirelessly to coordinate activities among at least five government agencies—a formidable task. After two precarious years, the Baker-Koren barn is now the Round Barn Farm Museum, owned by the Manhattan Township Park District.

BAKER-KOREN BARN
WILL COUNTY

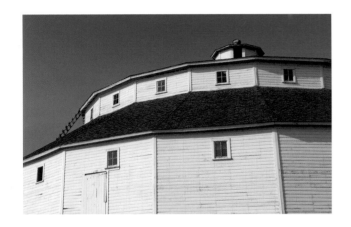

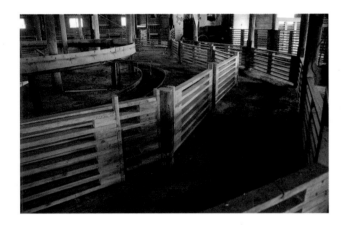

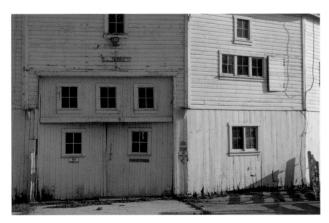

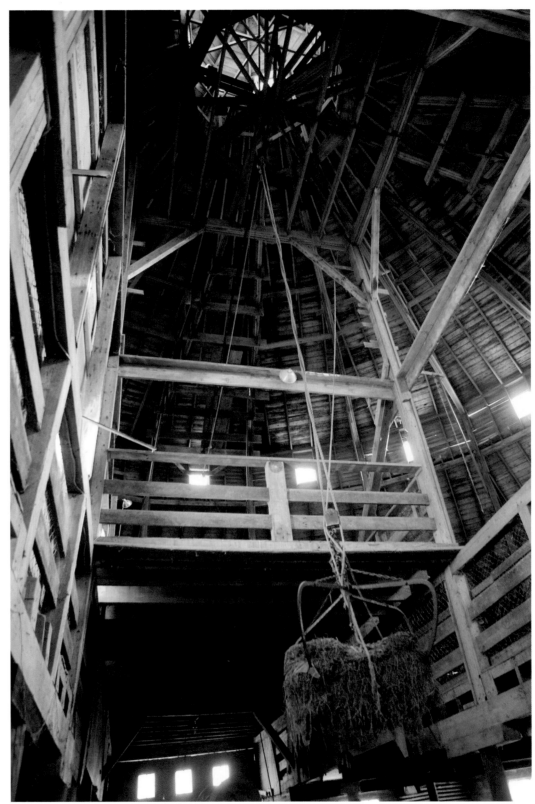

Young people today are fascinated by the history hidden in barns. Fifth-grade students in the Barn Buddies program at Tremont Grade School, coordinated by a teacher and librarian, Lori Fuoss, take part in a multidisciplinary investigation of barns in their region. As the students draw and photograph barns, interview owners, and research the history and architecture of the buildings, they gain a deep appreciation of the barns' roles in their heritage. Among other discoveries, the students have learned that President Martin Van Buren used a quill pen to sign the deed

to a barn in their area, that gambrel-roof barns were designed to store large numbers of supplies, and that a female pheasant can lay forty-five eggs a year. They share their understanding in a barn calendar they create each year. It is their attempt to preserve the barns and foster one more generation's passion for this American icon.

BARN BUDDIES
TAZEWELL COUNTY

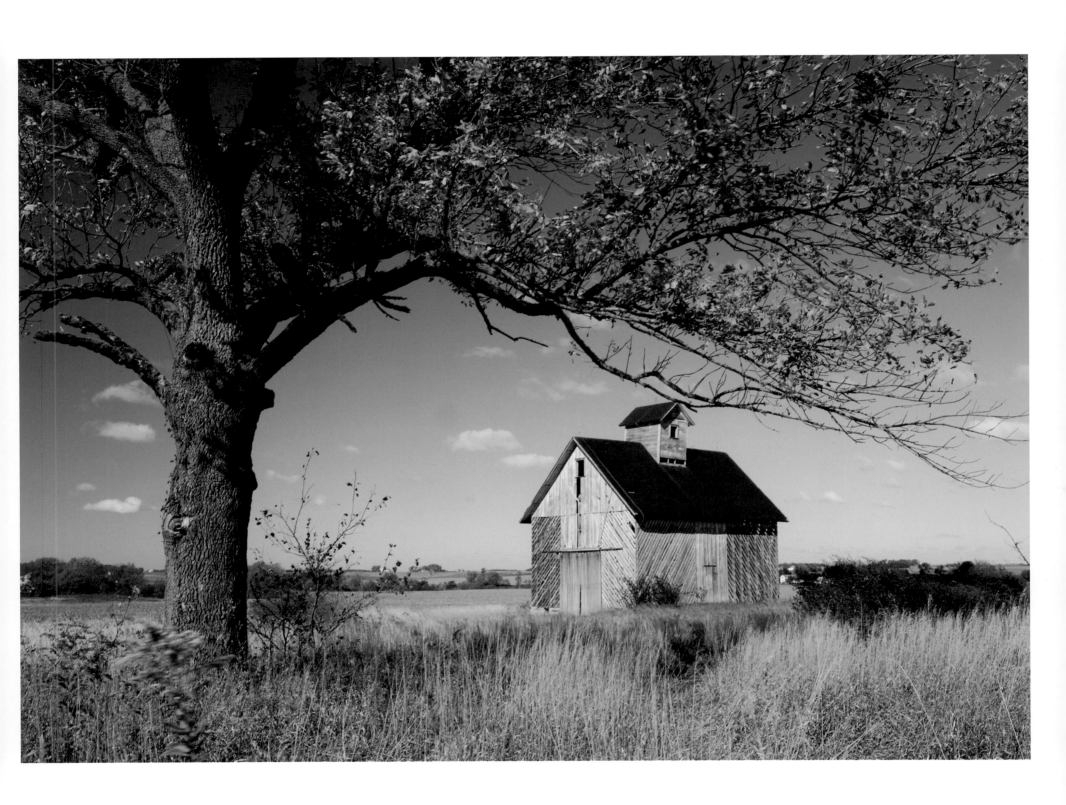

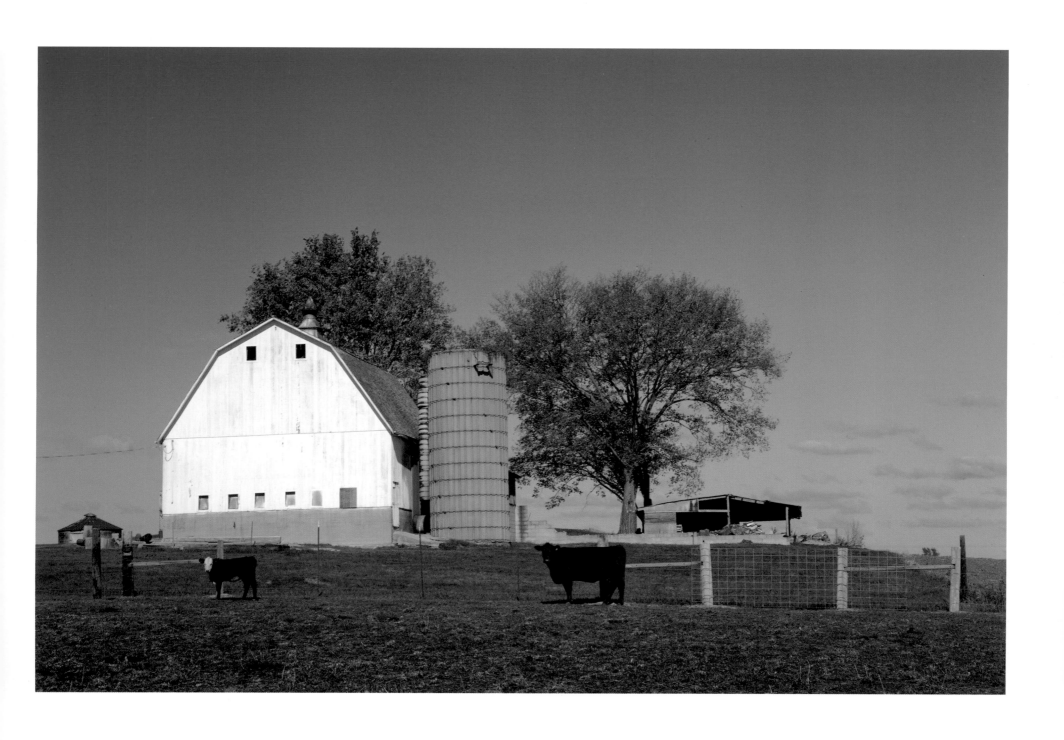

BARN BUDDIES

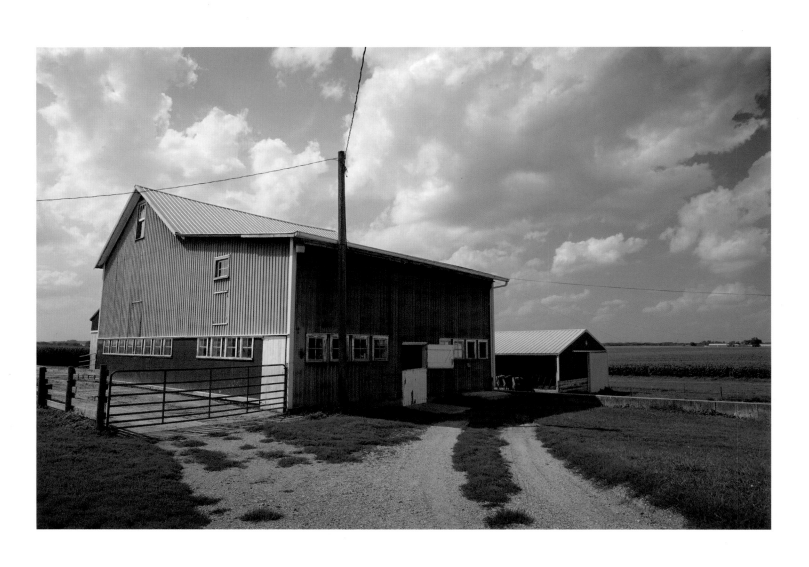

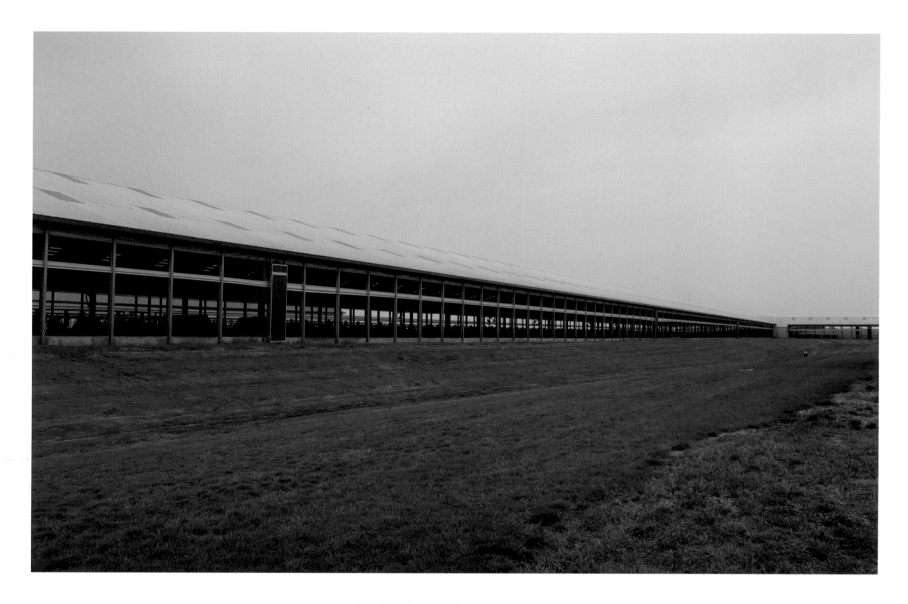

As the barns that dotted our landscape grow old and quaint, newer mega-barns that house hundreds or even thousands of cows are flourishing. With newer technologies and economies of scale, Illinois dairies make significant contributions to the state's commercial base, which includes producing nearly two billion pounds of milk annually. The mega-barns are living monuments on our landscape, a testimony to our agricultural history and base.

STONE RIDGE DAIRY
PIATT COUNTY

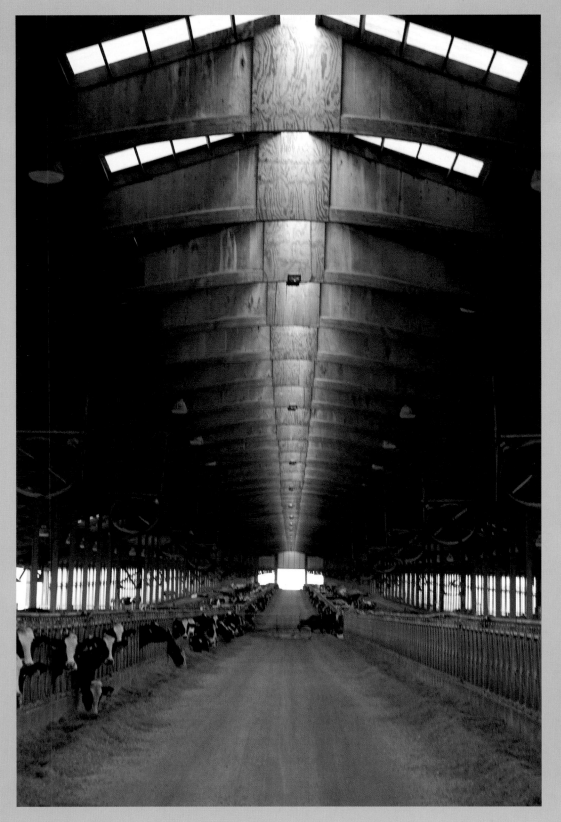
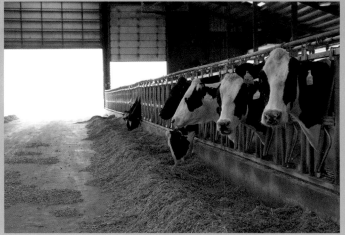

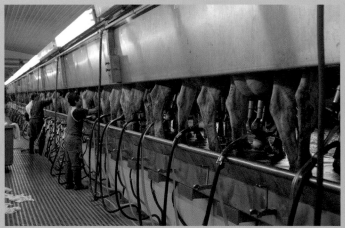

Many old barns no longer function as originally intended. The barns of yesteryear are not big enough to house modern farm equipment or the number of animals common on a modern farm. Their diminished usefulness, however, is only physical. Barns continue to hold social, emotional, cultural, and historic significance for us. Motivated by this, people are investing in a surprising range of new uses for the barns. With the barns' rebirth these buildings are becoming relevant in modern life, not just in memory. The physical structure of the barn remains a link to times past, and its reuse provides a new place for commerce, community, and cultural events.

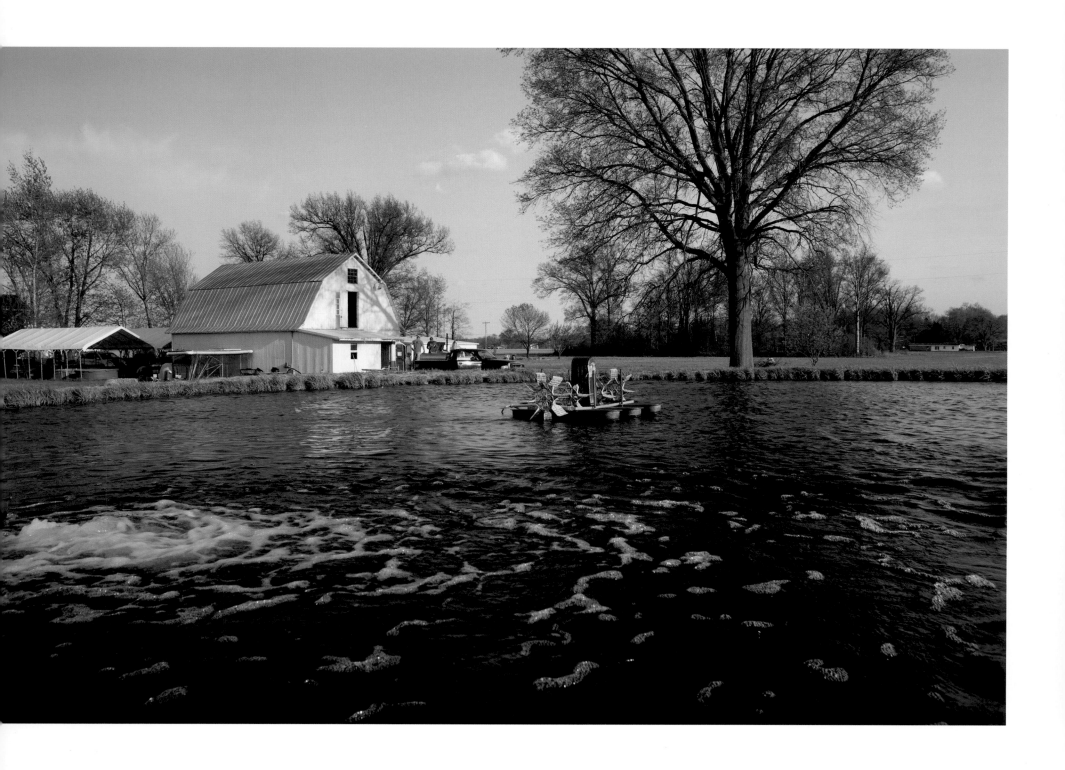

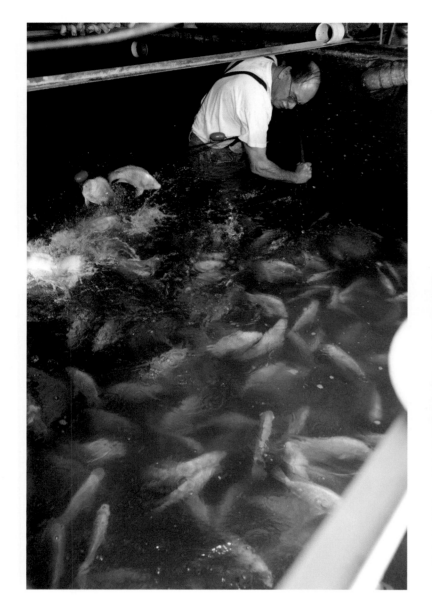

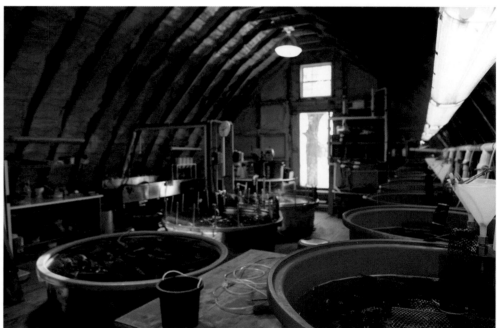

On the property owned by J.C. and Brenda Lyons is a barn built by J.C.'s grandfather. His grandfather moved the barn from its original site to where it stands today, progressing a little bit each day, during his time off from working at a nearby mine. In an unusual career move, J.C. and Brenda decided to delve into the fish hatchery business in the middle of Illinois corn country. Using the resources at hand, they completely renovated the barn to house a shrimp hatchery in the hayloft and fish and shrimp nurseries in the old stanchion areas of the barn. Their changes included adding electricity, ventilation, and substantial insulation to keep the fish warm. They needed special doors, and they built them right over the old barn doors. It would have been much easier, let alone less costly, to build a new structure specifically for raising fish. But this was an emotional issue, not an economic one. J.C. explains, "I couldn't tear down anything that my grandpa built with his own hands."

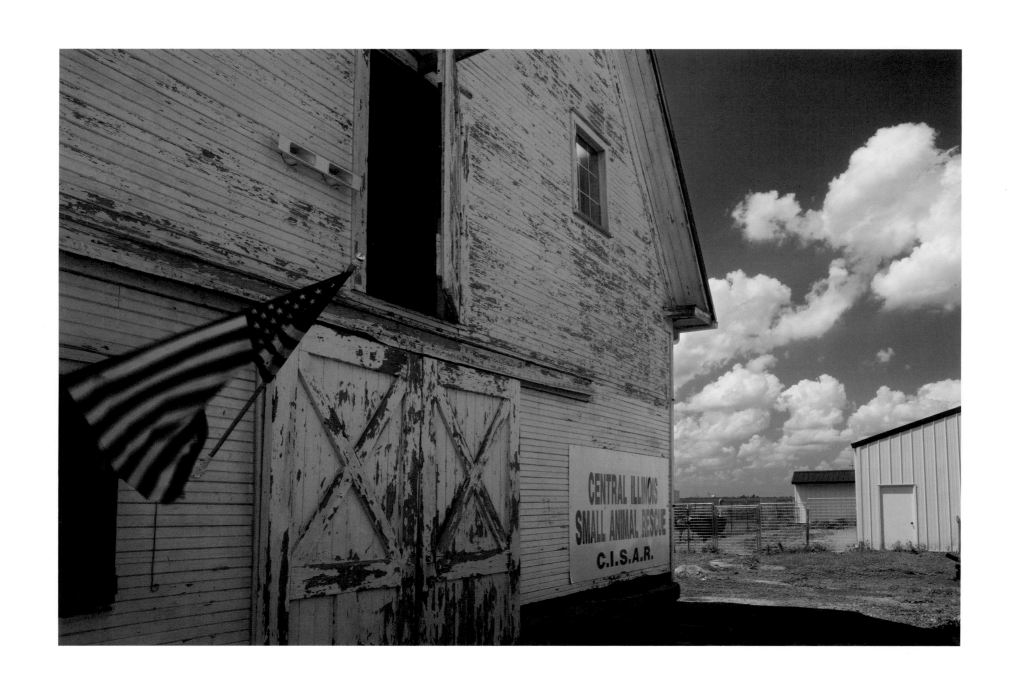

CENTRAL ILLINOIS SMALL ANIMAL RESCUE

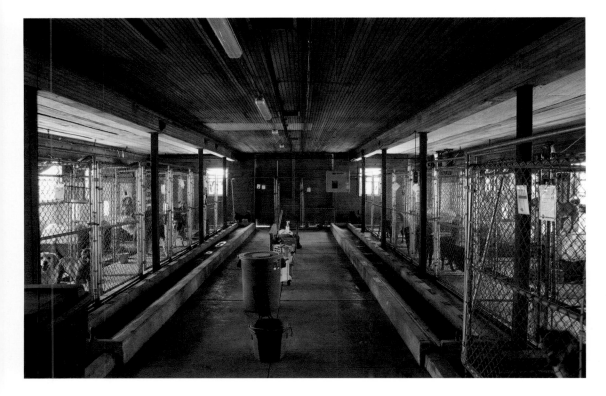

When you create a new use for a barn, it changes the place of that barn in the community. It involves new people and organizations that connect with barns in new and different ways. Pat and Garrie Burr were committed to animal rescue and were looking for a space that would be safe and secure for animals. They found this structure, built in 1917 as a typical horse and cattle barn. The Burrs bought the barn in 2003 and brought together new groups of people to renovate the barn as an animal rescue facility. The rooms inside the western portion of the barn were created as an Eagle Scout project. Inmates from a local jail helped renovate part of the barn for this reuse. The Burrs regularly work with various breed-rescue programs across the state, and today they shelter more than two hundred residents at a time and find homes for nearly sixty animals each month. Their animal rescue provides an opportunity for people to connect with an old barn in their modern lives.

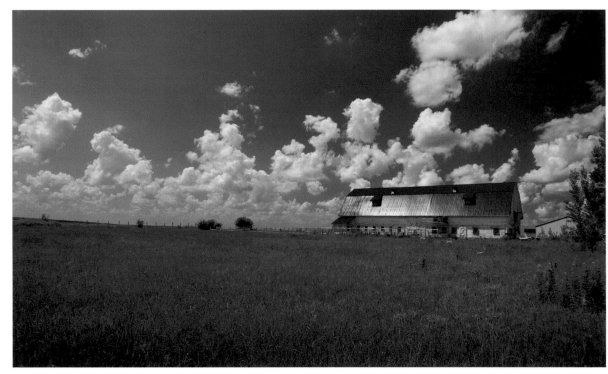

KLINE CREEK FARM

DUPAGE COUNTY

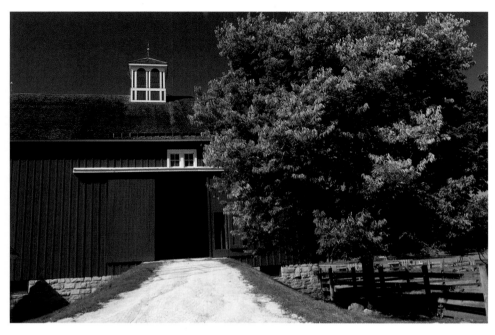

Generations of children living in the city have grown up with little first-hand knowledge about where their food comes from. To remedy this, the Kline Creek Farm, which includes a carefully restored barn, presents a living history of what life was like on a farm when the barn was built in the 1890s. Open to the public and hosting many field trips, the farm has a windmill for pumping water, an apiary with about 800,000 bees for producing honey, a smokehouse for preserving meat, a chicken coop for collecting eggs and fryers, and, of course, a barn. The upper barn stores hay and straw that feed the animals that provide us with meat and milk, and the lower barn displays cattle pens and milking stanchions.

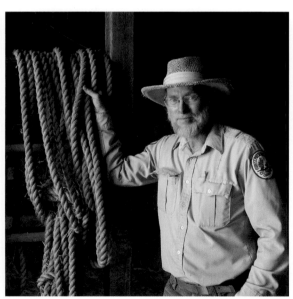

FINE LINE CREATIVE ARTS CENTER
KANE COUNTY

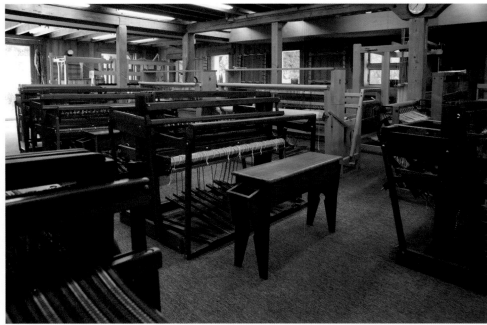

Sister Denise Kavanagh had a passion for weaving. She taught the craft to local aspiring artisans, and looms and weavers filled her small space in Geneva. As she sought out larger quarters for her studio and gallery, Sister Kavanagh contacted local school super-intendents to see if there were any abandoned schools she could purchase. The superintendent of neighboring St. Charles schools regretted that he did not have a school for sale, but he told Sister Kavanagh about a barn available across the street from his home. The space was perfect. What used to be a dog kennel in the barn has been transformed into a loom room, and the Fine Line Creative Arts Center is renowned in the greater Chicagoland area.

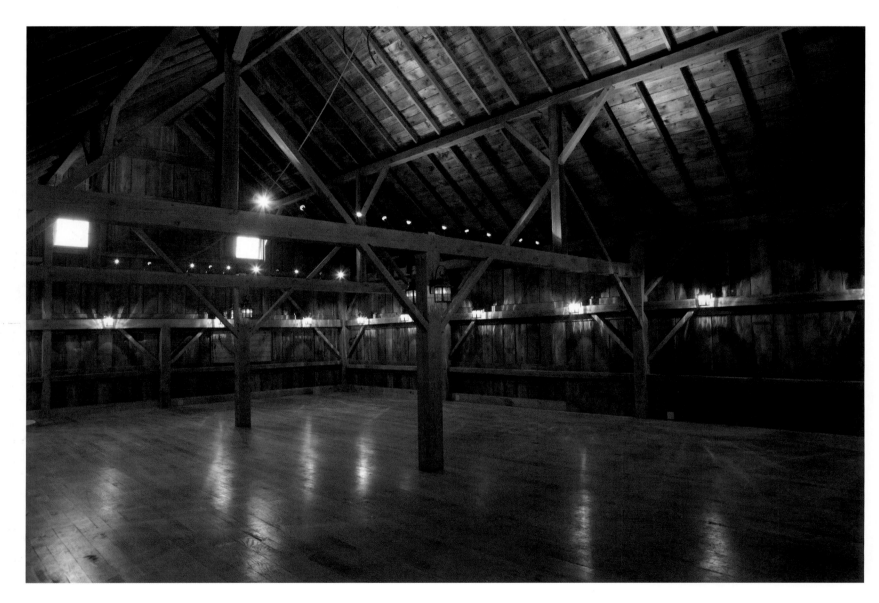

Midway Village Education Center moved and renovated this 1905 barn, which today can accommodate up to 275 students engaged in any one of its educational activities. The center creates a tie to the past by holding dances, theatrical performances, and other special events in the barn.

MIDWAY VILLAGE
WINNEBAGO COUNTY

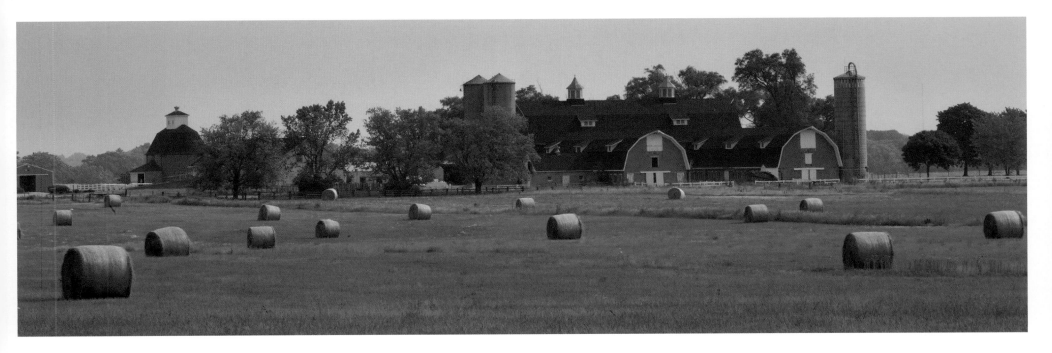

In 1913 the Loyal Order of Moose and the Women of the Moose, fraternal service organizations, established Mooseheart Child City and School, for children of deceased Moose members. The Brookline Dairy Farm was a perfect spot: near the center of North America, close to railroad lines, and with fertile soil for farming. Over time, the resident children spent less time on farm duties and more time in school. Applications are now accepted from all children in need. Living next to working farmland and observing how livestock is raised has provided a firm grounding for more than twelve thousand children who have lived in Mooseheart. Spreading goodwill, Mooseheart children regularly participate in service activities, such as corresponding with needy children in Uruguay and traveling to New Orleans to provide comfort and encouragement to victims of Hurricane Katrina.

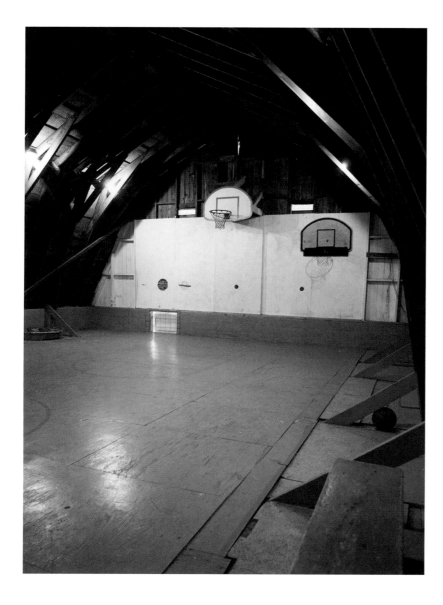

Nine Wortman children grew up playing in their family barn. There was a small section of the hayloft, cleared of hay, where siblings and friends could shoot hoops. Over time, the family farm had fewer and fewer animals. The Wortmans did not need so much hay, and so the basketball practice area grew. Today there is no hay, and the hayloft has been converted to a full-sized basketball court, enjoyed year-round by twenty-one Wortman grandchildren and their friends.

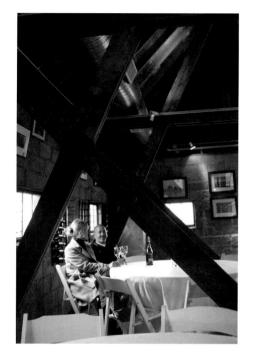

Matt LaMons was a successful mortgage banker during the booming 1990s. With the world moving online, however, he felt people were becoming detached from reality. Matt wanted to do something tangible, something real. He and his wife, Kristine, decided to build on Matt's hobby of making wine and turn it into a business that would provide people with an experience that would touch their emotions. They purchased a farmhouse that dates back to the Civil War and acquired the neighboring cinder-block barn to house their winery. Today the Ravissant Winery has fifty-eight American and French oak barrels and five large steel barrels, produces up to twelve separate wines each year, and hosts banquets, corporate dinners, weddings, and private tastings. Matt and Kristine are proud of their wines. Their dry red Norton wine won the gold medal in a California competition. But they do not want people to feel intimidated by the wine world or the vocabulary of vintners. What gives Matt and Kristine satisfaction is knowing that people come to the Ravissant Winery for good times with family and friends. And they credit their barn with creating such a comforting environment and putting people at ease.

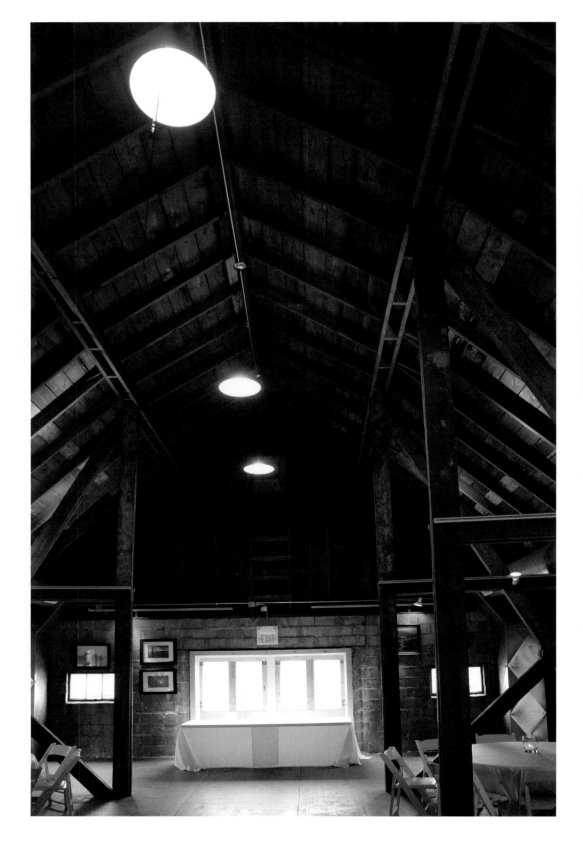

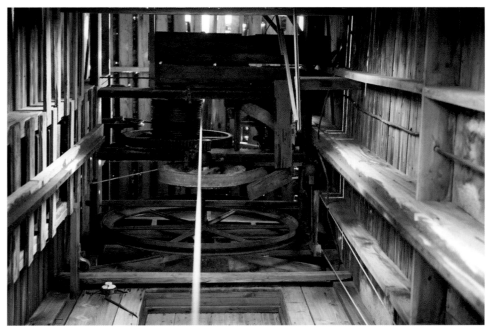

In the 1920s George Sheets built a typical barn to house his livestock near Macomb. In 1944, his son John converted that barn to an unusual-looking three-story chicken barn. This conversion was quite an undertaking. In order to outfit the barn for chickens, John built additional floors, insulated the entire barn with sawdust, cut out more than fifty windows, and even installed an electric elevator. Why so many windows? Chickens use the daily cycles of light and dark to produce eggs. At its most productive, this barn housed fifteen hundred hens, five hundred on each floor

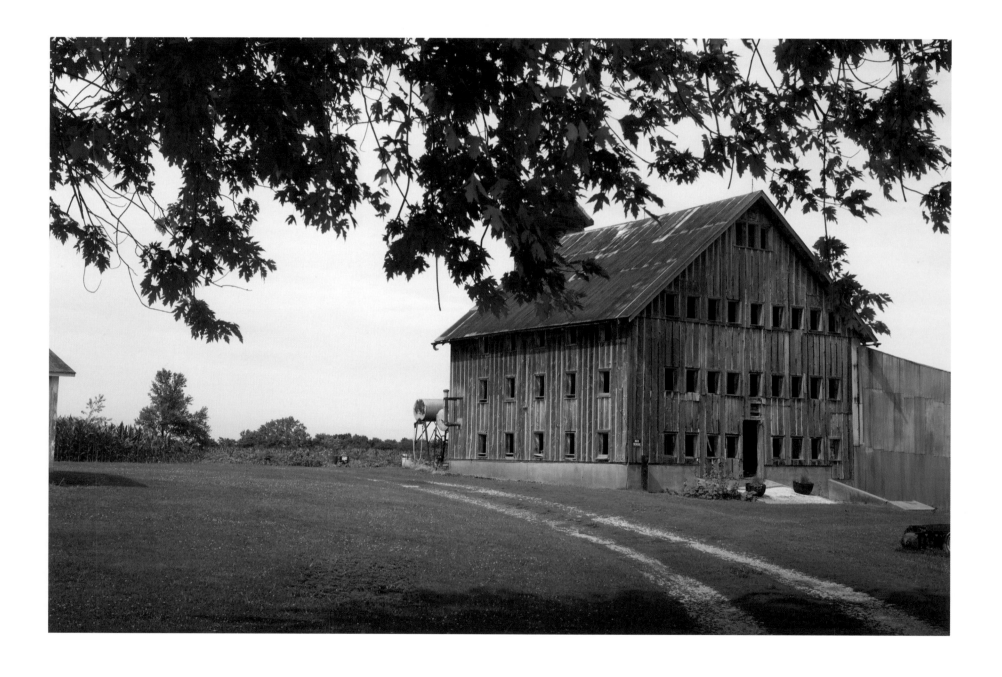

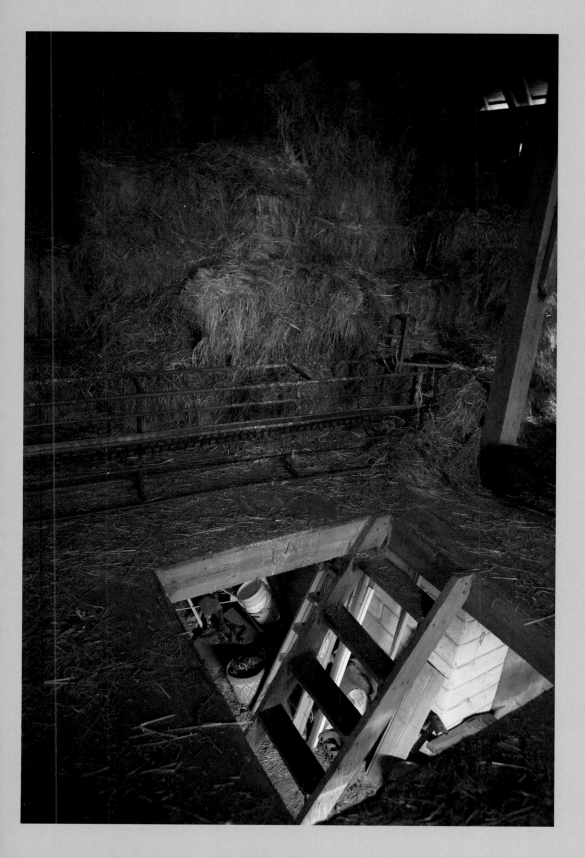

Inspiration

Illinoisans are a very resourceful people. They thrive on a delicate balance of independence and the goodness of their neighbors. They can innovate, work hard, and rise to any challenge. A single barn, laden with history, reminds us of this. The barn inspires us to think about what examples we are setting for future generations and motivates us to accomplish the unimaginable.

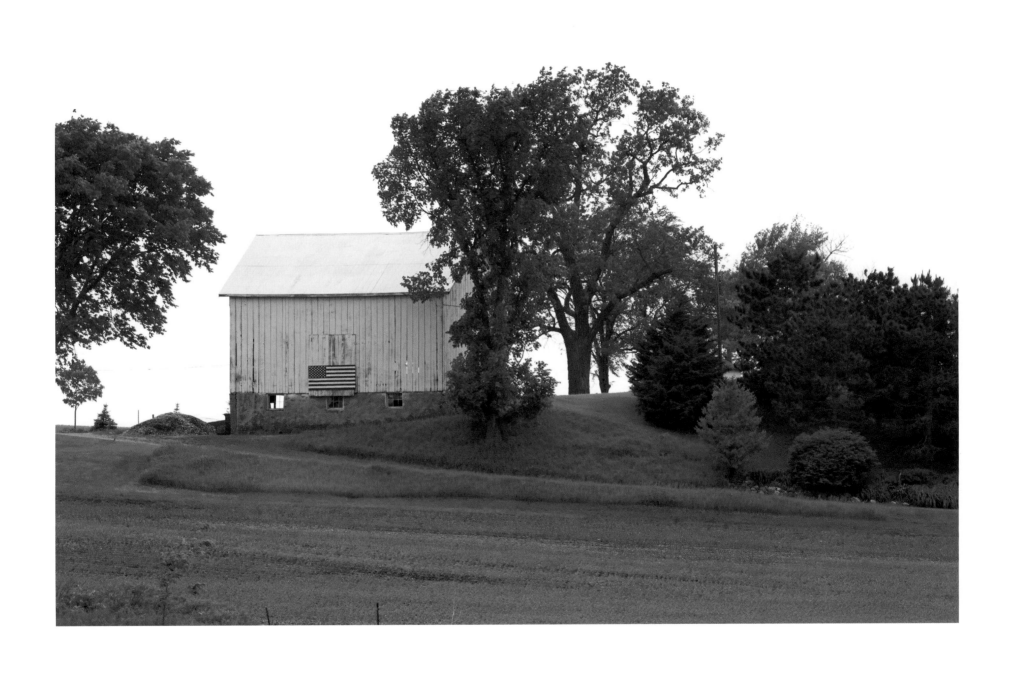

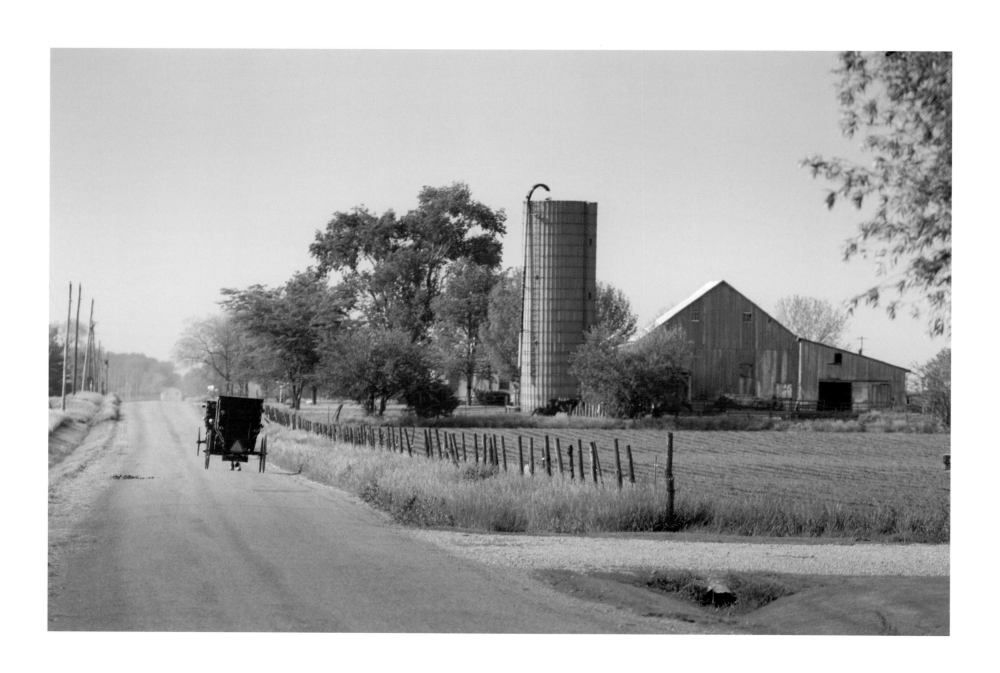

Like a center of gravity, a barn pulls people together over generations. In the 1890s, the community came together to help Emmanuel and Sarah Stover build their barn in Polo, Illinois. One fellow helping to build the barn met one of the girls cooking in the kitchen, and they married. One hundred years later, their grandson, still tied to the community, donated wood to help restore this barn for the Stovers' great-grand-son, Randy Ocken, and his wife, Nancy. And in 2000, Randy and Nancy's daughter, Carrie, was married in their barn, which continues to anchor important life events.

As Randy grew up, the barn kept the family close at hand. Randy's father always told him they could take a vacation, but they could travel only as far as they could get before having to return to milk the cows—and the cows were milked two times a day. This dedication taught Randy an appreciation for nature's bounty. He and Nancy invited their church congregation to their farm to commemorate their gratitude. Since 1982, the barn has been the gathering place for the Polo United Methodist Church Annual Celebration of Rural Life, bringing together the community for a blessing of the fields and a pot-luck dinner.

OCKEN BARN
OGLE COUNTY

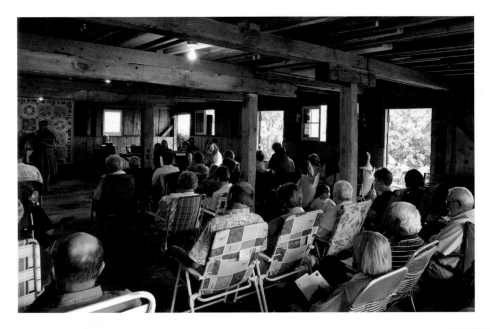

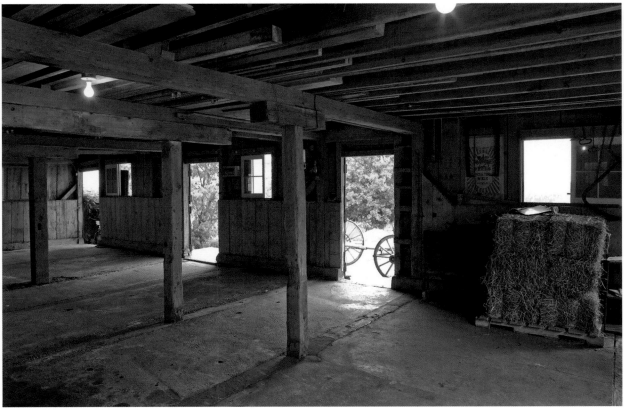

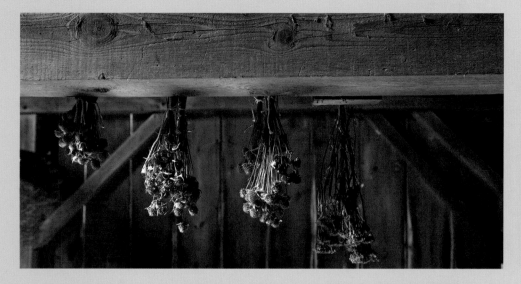

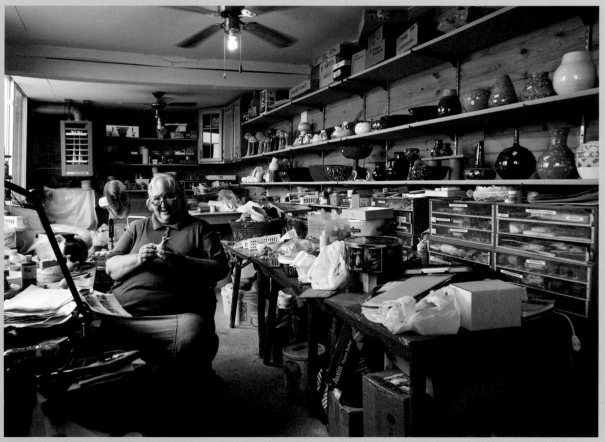

A Center for Ecology and Spirituality

Sister Sharon Zayac was on a mission to remember and reconnect to the earth. Recognizing that science and religion both point to the oneness of life, Sister Zayac sought to educate others about the importance of ecology and to provide people with a place to connect "to a story greater than themselves, one grounded in nature, history and community," as she wrote in her book Earth Spirituality. The Dominican Sisters' council supported Sister Zayzc's mission and purchased land in New Berlin, Illinois, for the Jubilee Farm: A Center for Ecology and Spirituality.

The Jubilee Farm was named to honor the Year of Jubilee, a time of spiritual renewal, repentance, and forgiveness in the Catholic Church, and also a time to let the land lie fallow. Today the Jubilee Farm offers open space and pastures, a labyrinth encouraging meditation and discovery, gardens, and a barn. The barn provides shelter for llamas, storage for straw, racks for drying harvested herbs, and a ceramics room where clay from the farm is transformed into useful and beautiful pottery.

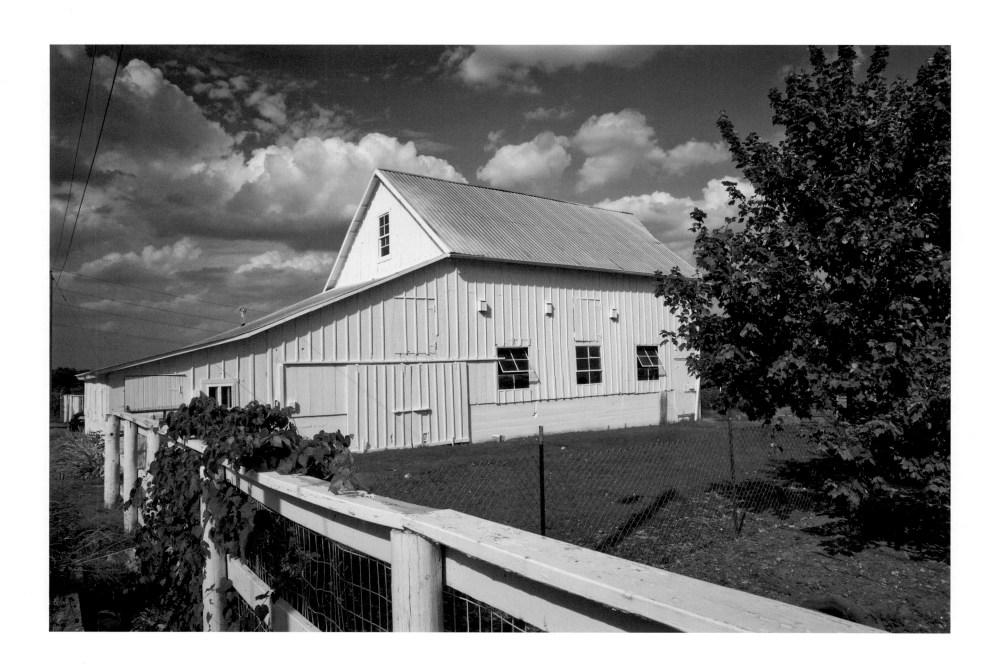

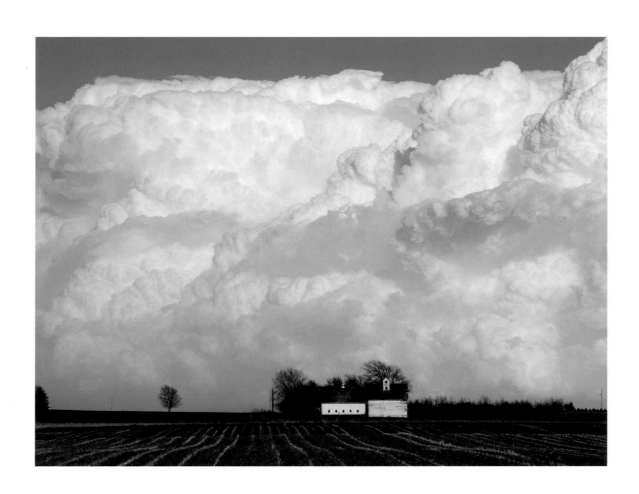

Acknowledgments

When we embarked on this project we tried to find the barn stories we envisioned through Internet and library research. That attempt turned up dry. We could not find the emotionally rich stories and histories we were looking for. But when we turned to people—the farmers, barn lovers, and friends of the Larry Kanfer Gallery from the past thirty years—the project came alive. We were overwhelmed with so many evocative descriptions of and emotional stories about barns that hundreds of people have shared with us.

Thanks to the following for helping to get the word out that we were looking for Illinois barn stories: Theresa Binion, Karen Fanale, Jim Fraley, Louise Greene, Pamela Henderson, Anne Hornyak, Dave McClain, Dave McClelland, Dave Mercer, Cynthia Nichols, Jenny O'Brien, Heather Pounds, John Small, Julie Stephens, and Tom Ward.

We are grateful to the barn owners who try to maintain these structures against the odds.

We deeply appreciate the time and energy the following people devoted to helping us to capture the tales of the barns featured in this book: Roger Anderson, Frances Barton, Pat and Garrie Burr, Tony Calabrese, Lynn Caldwell, Marv Causey, Aimee Chandler, Rick Collins, Suzanne Crandall, Tim Larson Dingus, Sister Suzanne Donner, Chick Flack, Lori Fuoss, Steve Gerdes, Glenn Gindler, Roger Grace, Wanda Hammond, Julie Hauter, Bernie Heisner, Dean Heisner, Esther Heisner, Melvin Heisner, Candace Kane, Ron Kipling, Julie Kurczewski, Matt LaMons, Carol LeRoy, Michael and Janet LeRoy, Rose Lober-Hamilton, J.C. and Brenda Lyons, Keith McClow, Darrell Mellema, Anne Meyer, Randy Ocken, John O'Dell, Vicky Padesky, Jerry Paulson, Mr. and Mrs. Chris Schweighert, Dan and Connie Schweighert, Brandee Stowe, Ken Teeple, Stephanie Todd, Katherine Walker, Kurt Wehrmeister, Bill Weidner, Dottie Williams, Brett and Julie Williamson, and David Wortman.

Dedicated groups of barn enthusiasts were a rich resource throughout the project, specifically Peg Bargon, Jean Cooper, Mark R. Edwards, Jean Follett and Jacquie Eddleman of the Illinois Barn Alliance, Harry Porter of Bement, Ron Ropp and Laurie Vial of the McLean County Barn Keepers, Judge Kent Slater, Brandee Stowe, Jim Williams, David Wilson, Wes Winter, and Wally Yoder.

For helping us see the ideas through to fruition we thank Willis G. Regier, Cope Cumpston, Lisa Bayer, Carol Betts, and others at the University of Illinois Press. Thanks for technical assistance also goes to Mark Barinholz, Marsha Michaelson, and Julie Taylor.

While we were working on this project many other people sent us suggestions about barns that still stand and barns held in memory, and they also referred us to other barn enthusiasts. Their stories would fill volumes. They've inspired us. Thanks go to Walter Adams, Nancy Anderson, Deb Aronson, Max Baumgardner, Nolan Bello, Michelle Bergman, Janene Blodgett, Michael Bork, Julie Bounds, Ida Boyle, Lee W. Brokaw, Michael Brown, Ed Brumley, Dave and Karen Butler, Vance Buzzard, Susan Cadie, Peggy Chandler, Sheila Chapman, Ron and Debra Charles, Sharon Clemens, Margaret Cline, Sheryl Cohen, Mark Coleman, Mark Coon, Susan and Carroll Cox, Julie Darrow, Lenette DiCiaula, Alice Dilts, Jean Dilworth, Bill Doerge, Scott Drabont, Jim and Deb Dronenberg, Sandy and Mike Dunphy, Mark Edwards, Cheryl Fippen, Barbara Frahm, Janna Franks, B. Fuller-Curry, Andrew Furbee, Shannon Ganschow, Jerry Gash, Susan Getz, Mary S. Gilbert, Dale Goodner, Ellen Gray, Matthew Gray, Mary E. Gregoire, Sandy Haas, Gary Hacker, Bruce Hannon, Michael Harker, Paula Heath, Marje Herron, Mel Holycross, Paul Honnold, Joyce A. Hudson, Kristin Huls, Melvin Huls, Amanda Huston, Catherine Johnson, Laura Jordan, Anita Kaufman, Elizabeth Kerns, Nancy Kiedaisch, Janis King, Ken Konsis, Becky Kuchefski, Mike Lambert, Margaret Larson, Tom Laughlin, Kate Legge, Roman and Jean Lenart, Steve Litchfield, Mary Eleanor (Baxter) Logan, Mike Long, Jeanne and Orville Lubbe, Jim Lukeman, Ellie Maroon, Darrell McAfee, Caroline McNair, Jim Mentesti, Ann Meyer, F. Gene Miller, Janet Miller, Nicole Miller, Mark Minier, Faye Mize, Sally Morris, Denise Myatt, Marsha Neitzel, Richard Newman, Jack Ottosen, Shelley Libka Place, Michael Preis, Judith Puckett, Nick Rave, Kathryn Reeves, Betty Hunt Rice, Donald and Betty Rice, Gary and Diane Richards, Dale Robb, Diana Ropp-Green, Kathleen Ruffus, Laurie Rund, Luis Rund, Maria Rund, Karen Sayers, Emily Schirding, Barb Schurter, Joseph Seibold, Janet Semanik, Bruce Shanle, Marion Shier, Anne Silvis, Jim and Eleanor Smith, Karen Smith-Cox, Michael Spencer, Maureen Squires, Darlene Stahl, Ed Stoller, Neil Strack, Earl R. Swanson, Judy Swartzendruka, Joseph E. Thompson, Ed Tiedemann, Terrie and Alexa Tuntland, Susan Vinson, Virginia Vinson, Kathy Wahlberg, Sheila Walk, Bill Waters, Peggy Wells, Brent Wheeler, Pat White, David Wilson, Martha Winter, and Sandy Wolfram.

Finally, thanks to so many others whose names have not been listed but who have shared their passion for barns, or for a particular barn, over the years.

Please keep sharing.

The Photographs

52 Outside Dwight, Livingston County. Photographed with the permission of Karl Kohrt.

53 Outside Dwight, Livingston County.

54 Formerly the Chandler Barn, near Buckley, Iroquois County. Present owner unknown.

55 Cornwell farmstead from the air, Savoy, Champaign County. Owned by Ray and Carolyn Cornwell.

57 A round barn near Tampico, Lee County. Owner unknown.

58 Near Leroy, McLean County. Owner unknown.

59 Outside Elliott, Ford County. Owner unknown.

60 East of Bloomington, McLean County. Owner unknown.

61 TOP LEFT: Ausbury Barn, photographed from the road, east of Macomb, McDonough County.
TOP RIGHT: Jubilee Barn, New Berlin, Sangamon County. Photographed with the permission of the Dominican Sisters, OP, Springfield.
BOTTOM LEFT: North of Good Hope, McDonough County. Owned by Johnie Allen Jr.
BOTTOM RIGHT: Near Bellflower, McLean County. Owner unknown.

62 TOP: Near Cobden, Union County. Owner unknown.
MIDDLE: Photographed from the road in Lee County. Owner unknown.
BOTTOM: East of Pekin on Broadway, Tazewell County. Photographed with the permission of Mrs. Don Wagler.

63 TOP: Lee County. Owner unknown.
MIDDLE: East of Macomb on Route 136, McDonough County. Photographed with the permission of Charles Flack.
BOTTOM: South of Tremont, Tazewell County. Photographed with the permission of Mr. and Mrs. Chris Schweigert.

64 Interior views of a barn along Route 20, southeast of Galena, Jo Daviess County. Photographed with the permission of William and Catherine Winslow.

65 Interior views of a barn along Route 20, southeast of Galena, Jo Daviess County.

66 Between Sidney and St. Joseph, Champaign County. Photographed with the permission of the Fippen family.

67 East of Galena, Jo Daviess County. Owner unknown.

69 South side of Champaign, Champaign County. Owner unknown.

70 Teeple Barn, Elgin, Kane County. Photographed with the permission of the Fischer Nut Company.

71 Teeple Barn

72 Teeple Barn

73 Interior of the Teeple Barn

74 Williamson Barn, Neoga, Cumberland County.

Photographed with the permission of Brett and Julie Williamson.

75 Williamson Barn

76 University Beef Barn, originally built in Champaign, Champaign County, being readied for its move to Monticello, Piatt County. In the lower right, the barn is shown dismantled and in storage in its new location. Photographed with the permission of the Piatt County Museum.

77 University Beef Barn with part of its roof removed, before being moved.

78 Aldeen Barn, Aldeen Golf Club, east side of Rockford, Winnebago County. Owned by the Rockford Park District.

79 Aldeen Barn

80 Interior details of the barn on the grounds of the Shawnee Hill Bed and Breakfast, Cobden, Union County. Photographed with the permission of Tony and Rhea Calabrese.

81 On the grounds of the Shawnee Hill Bed and Breakfast

82 Koren-Baker Barn, southeast of Joliet, Will County. Owned by the Manhattan Park District.

83 Details of the Koren-Baker Barn

84 Southeast Tazewell County. Owner unknown.

85 TOP LEFT: Mr. and Mrs. Chris Schweigert. Photographed with the permission of Mr. and Mrs. Chris Schweigert.
TOP RIGHT: Tremont Grade School teacher Lori Fuoss with barn buddy students, Tremont, Tazewell County. Photographed with permission of Lori Fuoss and parents of the students.
BOTTOM RIGHT: Date on the foundation of a barn south of Morton, Tazewell County. Photographed with the permission of Mrs. Don Wagler.

86 Outside Tremont, Tazewell County. Photographed with the permission of the Steffey family.

87 South of Tremont, Tazewell County. Photographed with the permission of Mr. and Mrs. Chris Schweigert.

88 Stone Ridge Dairy, near Mansfield, Piatt County. Photographed with the permission of George Kaspbergen.

89 Stone Ridge Dairy

91 Northern Jo Daviess County. Owner unknown.

92 Lyons Fish Hatchery, Sandoval, Marion County. Photographed with the permission of Brenda and J. C. Lyons.

93 Lyons Fish Hatchery

94 Central Illinois Small Animal Rescue, Colfax, McLean County. Photographed with the permission of J. Garrie and Pat Burr.

95 Central Illinois Small Animal Rescue

96 Kline Creek Farm, west of Wheaton, DuPage

County. Owned by the Forest Preserve District of DuPage County.

97 Kline Creek Farm, with Howard Sergeant, Heritage Interpreter.

98 Fine Line Creative Arts Center, an independent not-for-profit entity in St. Charles, Kane County. Photographed with the permission of the Fine Line Corporation, Lynn Caldwell, director.

99 Fine Line Creative Arts Center.

100 Midway Village Education Center, Rockford, Winnebago County. Owned by the Rockford Park District.

101 Mooseheart Child City and School, Mooseheart, near Batavia, Kane County. Photographed with the permission of Mooseheart Child City and School Inc.

102 Wortman Barn, west of Effingham, Effingham County, has been retrofitted with a basketball court and decorated at its gable end. Photographed with the permission of the Wortman family.

103 Wortman Barn

104 Ravissant Winery, Belleville, St. Clair County. Photographed with the permission of Matt and Kristine LaMons.
TOP: Robert and Tammy Corrie enjoy the Ravissant Winery. Photographed with the permission of Robert and Tammy Corrie.

105 Details of the Ravissant Winery, Belleville, St. Clair County.

106 Details of the Kipling Chicken Barn, Marietta, McDonough County. Photographed with the permission of Ron Kipling.

107 Kipling Chicken Barn, Marietta, McDonough County.

108 A barn in rural Cooksville, McLean County. Photographed with permission of Jim Fraley.

109 The haymow in the rural Cooksville barn.

110 A barn west of Princeton, Bureau County. Owner unknown.

111 Amish buggies pass by a barn south of Arthur, Moultrie County. Owner unknown.

112 Ocken Barn, Polo, Ogle County. Photographed with the permission of Randy and Nancy Ocken.

113 Ocken Barn; Celebration of Rural Life.

114 Jubilee Farm, New Berlin, Sangamon County. Photographed with the permission of the Dominican Sisters, OP, Springfield.

115 Jubilee Farm

116 A barn dwarfed by cloud cover near Urbana, Champaign County. Owner unknown.

AUTHOR NOTE: Francis Barker with Phelps Barn, Elmwood, Peoria County, owned by Elmwood Community Foundation.

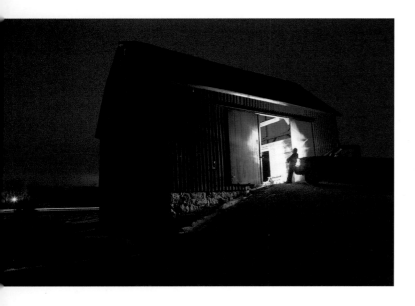

Larry Kanfer is a Midwest-based artist. He was born in St. Louis, moved with his family from east to west and then back to the Midwest, where he earned a degree in architecture from the University of Illinois at Urbana-Champaign.

Since opening his photography gallery almost thirty years ago, Kanfer has had the rare opportunity to make his art his career. He has drawn praise from ARTNews, the Associated Press, the Washington Post, and others for his remarkable ability to identify what people love about a place and to convey that in two dimensions. Today the galleries in Champaign, Illinois, and online at www.kanfer.com offer original artwork as well as books and award-winning calendars. His publications include *Prairiescapes* (1987), *On This Island: Photographs of Long Island* (1990), *On Second Glance: Midwest Photographs* (1992), *Postcards from the Prairie: Photographic Memories from the University of Illinois* (1996), and *On Firm Ground: Photographs by Larry Kanfer* (2001). His original artwork is featured in public and private collections nationally.

Alaina Kanfer grew up in Chicago and went to graduate school at the University of California in Irvine, where she received her doctorate in mathematical social sciences. She moved to Champaign, Illinois, to take a research position at the University of Illinois, where she founded a research group at the National Center for Supercomputing Applications and published numerous scientific articles on social networks and the social impact of technology. In Champaign, she fell in love with her husband, Larry, and the Illinois prairie. She and Larry live in Champaign with their two children, Anna and David, and their two cats.